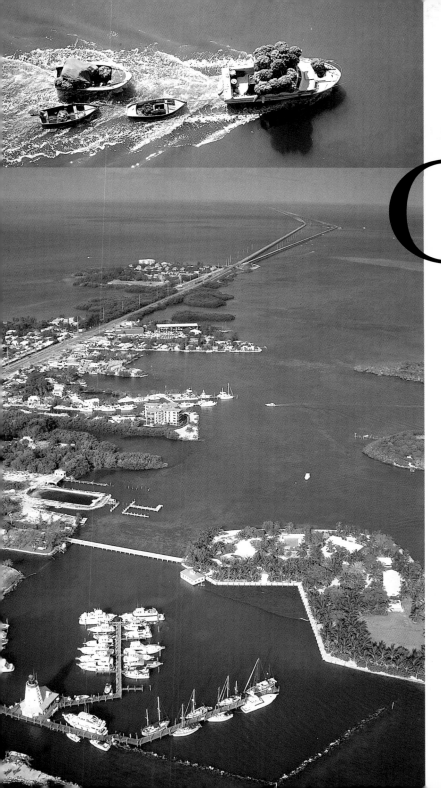

Over Key West
and the Florida Keys

Charles Feil

 PINEAPPLE PRESS, INC.
Sarasota, Florida

ACKNOWLEDGMENTS

Though I work solo as both pilot and photographer, family, friends, and strangers have unselfishly come to my aid in paving the way to the successful completion of this book. They have supported me with a place to lay my head at night, fuel for my mind and body, or hangar space for a tired Rooty at the end of a long day of flying. Thanks to Maralyce Ferree for her unwavering love and support of my passions and goals; to my son, Dylan, whose sensitive insights keep the fire in my soul aglow; and to Ken and Maria Feil for sharing their extensive knowledge of the Keys and offering me bunk space on their trawler. Thanks to my parents, brothers, and friends, who have been avid supporters of my books and projects throughout my career. Special thanks to James Wyatt of Wyatt Aviation in Homestead, Florida, for pointing out Deer Key and allowing Rooty and me to hang our rotors and hat, respectively, at his flight base operations; to Rob and Debbie Grant of Grant Aviation in Marathon, Florida, for sharing their knowledge of the middle Keys and offering hangar and camping space at their flight base operations; and to John Viele for his sharp editing and for adding his invaluable knowledge of the Keys to the text of this book. Last, but not least, thanks to David and June Cussen and the editorial staff at Pineapple Press for their belief in and promotion of this unique view of the Florida Keys. ☀

Inquiries should be addressed to:

Pineapple Press, Inc.
P.O. Box 3889
Sarasota, Florida 34230

www.pineapplepress.com

Library of Congress Cataloging-in-Publication Data
Feil, Charles, 1948–
 Over Key West and the Florida Keys / Charles Feil.— 1st ed.
 p. cm.
 ISBN 1-56164-240-1 (alk. paper)
 1. Key West (Fla.)—Aerial photographs. 2. Florida Keys (Fla.)—Aerial photographs. I. Title.

F319.K4 F45 2001
975.9'41063'0222—dc21
 2001036358

First Edition
10 9 8 7 6 5 4 3 2

Design by Carol Tornatore
Printed in China

Ten Keymandments on page 6 courtesy of Monroe County (Florida Keys) Tourist Development Council (www.fla-keys.com)

CONTENTS

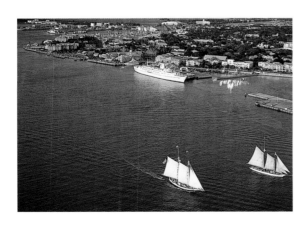

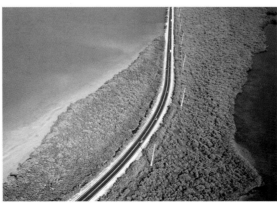

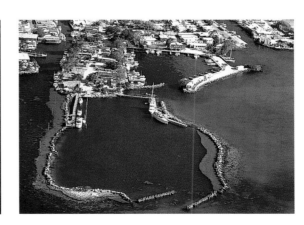

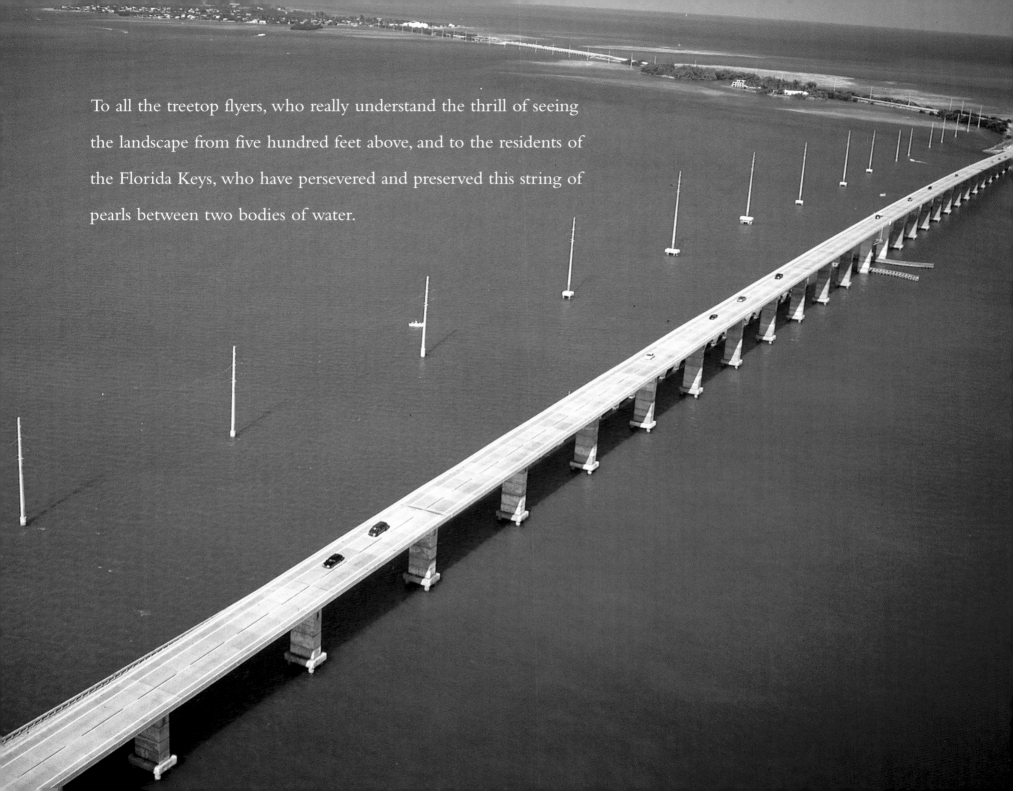

To all the treetop flyers, who really understand the thrill of seeing the landscape from five hundred feet above, and to the residents of the Florida Keys, who have persevered and preserved this string of pearls between two bodies of water.

INTRODUCTION

Florida, the Sunshine State, evokes images of endless blue skies, warm waters, golden sunsets, sugar-white beaches, and palm trees lining the streets of stucco homes with red-tiled roofs. The Florida Keys, flung out below the peninsula, evoke pictures of even bluer skies, warmer turquoise waters, and wanton celebrations of those golden sunsets. My mind's eye played with these images as I headed south on I-95 out of Portland, Maine, on a cold January afternoon. I was embarking on a new photographic journey to discover the Florida Keys from the air. As the tires hummed in rhythm over the fifteen hundred miles of highway ahead, I thought about the "snowbirds," those human winter residents who, like the snow geese, head south as the trees lose their leaves. Is it temperature, sunshine, or the quality of life that attracts these creatures of habit to find yearly solace on these thin slivers of islands that slice and separate the great waters of the Atlantic Ocean and Gulf of Mexico?

With my gyroplane named *Rooty Kazooty* in tow and my camper securely strapped to my pickup bed, I was on my way to explore these latitudes with an open attitude. I arrived at Plantation Key Yacht Club at Mile Marker 77 on a sweltering hot evening. I was spending the night with Ken and Maria Feil, relatives

who live on a trawler on the bay side of the Keys. It was a pleasant time of steaks on the grill, beer in hand, and a year's worth of catching up on each other's travels. Having lived in the Florida Keys for over a decade, Ken and Maria filled me in on places I should fly over for either their uniqueness or historical significance.

My usual strategy when arriving at a new airport is to scope out who's in charge and plead my case as a photographer on a mission. This usually gets me hangar space for *Rooty* and a place to park my camper for a few days. James Wyatt of Wyatt Aviation was more than generous in supporting my stay in the area.

Altogether, I spent three weeks flying and photographing from Florida City to Key West. From my lofty perch of five hundred feet, I viewed the string of island pearls we call the Keys, joined to each other by the bridges of the prettiest highway in the world. I flew over diverse communities that cling to real estate made of coral, shell, and sand. I swooped down to see protected sea and wildlife preserves that save the past for the future. I cruised low over relics of engineering genius from leaders like Henry Flagler, who had the vision and perseverance at the turn of the century to link a railroad from the top of the state to the widely

scattered homesteads of south Florida, and then in 1912 over sea and land down the Keys all the way to Key West.

For *Rooty* and me, it was an opportunity to explore these skinny patches of land that head south and west to the southernmost point of the continental U.S.A., and along the way to view magnificent sunrises reflecting off bay windows of beach homes at Key Colony Resort, and to be mesmerized at the end of the day by molten orange sunsets at Key West. What wonderful, magical moments we had flying with pelicans in formation over uninhabited wilderness areas, as a lone skipper below expertly navigated his boat full of sponges through a narrow channel in Jewfish creek.

I offer you these images as proof that magic exists. When you drive down the Keys on the Overseas Highway, you begin to sense it; when you arrive by boat, you feel it deep inside; and when you fly over those Keys, you just *believe*. The Florida Keys seen from above reveal a magical tropical paradise, with Key West as the pot of gold at the end of the rainbow! ☀

THE TEN KEYMANDMENTS

1. Don't anchor on a reef. (Reefs are alive. *Alive*. A–L–I–V–E.)

2. Don't trash our place. (Or we'll send Bubba to trash yours.)

3. Don't speed. (Especially on Big Pine Key, where Key deer reside, and tar-and-feathering is still practiced.)

4. Don't collect conch. (This species is protected. By Bubba.)

5. Don't damage the sea grass. (And don't even think about making a skirt out of it.)

6. Don't feed the animals. (They'll want to follow you home. And you can't keep them.)

7. Don't touch the coral. (After all, you don't even know them).

8. Don't catch more fish than you can eat. (Better yet, let them go. Some of them support schools.)

9. Don't disturb the bird nests. (They find it *very* annoying.)

10. Don't drink and drive. On land or sea. (There's absolutely nothing funny about it.)

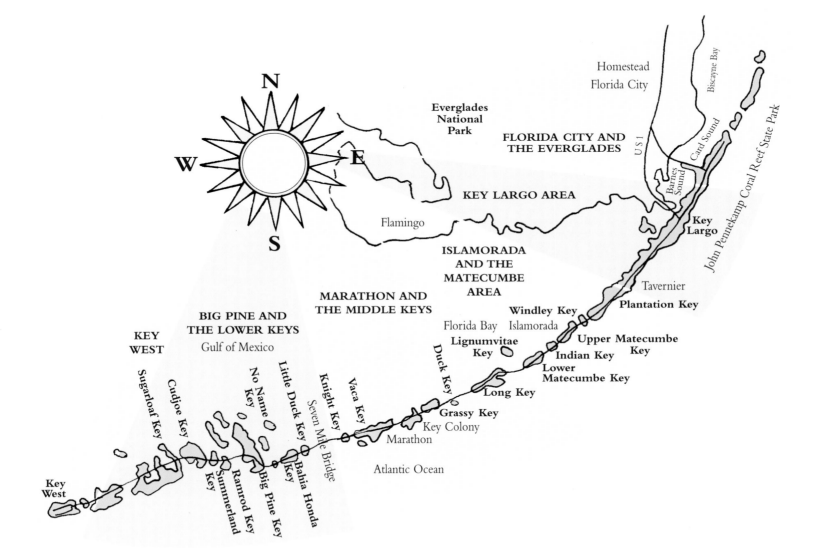

N

W E

S

Homestead
Florida City

Everglades
National
Park

Biscayne Bay

**FLORIDA CITY AND
THE EVERGLADES**

US 1

Card Sound

Barnes Sound

KEY LARGO AREA

Key
Largo

Flamingo

John Pennekamp Coral Reef State Park

Tavernier

Plantation Key

**ISLAMORADA
AND THE
MATECUMBE
AREA**

**MARATHON AND
THE MIDDLE KEYS**

Windley Key

Florida Bay Islamorada

**BIG PINE AND
THE LOWER KEYS**

**KEY
WEST**

Gulf of Mexico

**Lignumvitae
Key**

**Upper Matecumbe
Key**

Indian Key

**Lower
Matecumbe Key**

Duck Key

Long Key

Grassy Key

Vaca Key

Knight Key

Little Duck Key

No Name
Key

Seven Mile Bridge

Key Colony

Marathon

Sugarloaf Key

Cudjoe Key

Summerland
Key

Ramrod Key

Big Pine Key

Bahia Honda
Key

Atlantic Ocean

Key
West

7

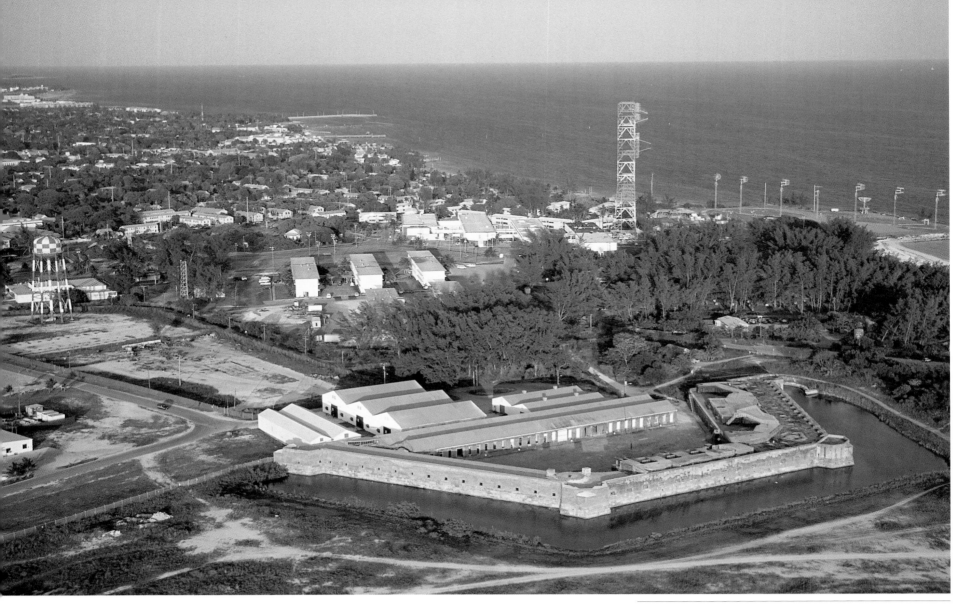

Fort Zachary Taylor, named for President Zachary Taylor, stands near the southwestern point of Key West, guarding the main ship channel entrance to the harbor. Construction began in 1845, the same year Florida became a state. During the Civil War, the fort was important for the defense of Key West, the only southern port to remain in Union hands. In 1968, excavations revealed a buried arsenal of Civil War cannons thought to be the largest collection in the United States.

KEY WEST

Capital City of the Conch Republic

Key West is a quixotic blend of legends, life-styles, and geography. Early Spanish explorers are said to have found the island littered with bones from the Indians who had lived there. The Spaniards thus named it *Cayo Hueso*, Spanish for "Island of Bones." Since it is the westernmost of the populated Keys, the *hueso* (pronounced "wesso") became "west" in English and thus Key West.

The next naming came in 1982, when the US Border Patrol placed a roadblock on US 1 just before it crosses into Key Largo to intercept drug traffic and illegal aliens. Traffic jams resulted and it basically shut down tourism. Outraged locals came together, formed the nation of the "Conch Republic"

and seceded from the Union. The new nation instantly surrendered to the United States and demanded one billion dollars in foreign aid. The stunt worked and the roadblocks ended. The Conch Republic flag still flies in the skies above the Keys, and Conch Republic "passports" are also issued.

Singer Jimmy Buffet has also helped to enhance the Keys "state of mind" with his songs "Margaritaville" and "Cheeseburger in Paradise." Key West is closer to Havana (90 miles) than to Miami (159 miles). Because of its unique geography as the southernmost point of the continental United States—the end of the line—it supports a certain unconventional sense of celebration. Each day's

setting sun is celebrated at Mallory Dock, while artisans, musicians, and street performers pack the city pier with visitors as the famed and often magnificently memorable Key West sunsets shimmer over the emerald waters of the Gulf of Mexico. Key West attracts every walk of life, from presidents (Harry Truman), writers (Ernest Hemingway and Tennessee Williams), and treasure hunters (Mel Fisher), to street orators like Rob, who stands on a soapbox and preaches to the crowd wearing a shark's fin hat with two beer cans attached.

Flying over Key West at sunset has its own unique charm. You feel a part of the celebration, but with the best views.

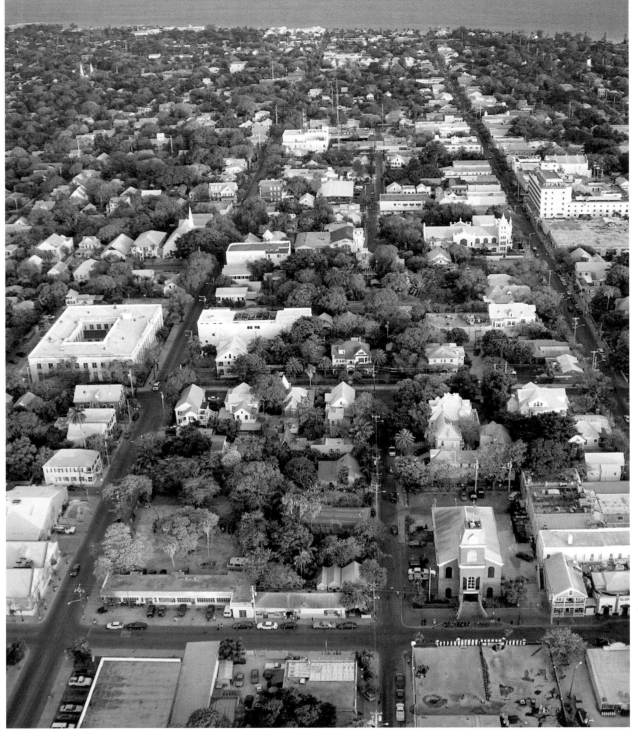

Key West is the final stop on the Overseas Highway, where the road ends and meets the sea amid nineteenth-century charm and twentieth-century attractions. The ambiance of this lively, subtropical tourist town is embedded in the narrow, tropical tree–lined streets, historic gingerbread mansions built a century ago, and a diverse citizenry, including native-born "Conchs," descendants of nineteenth-century immigrants from the Bahamas.

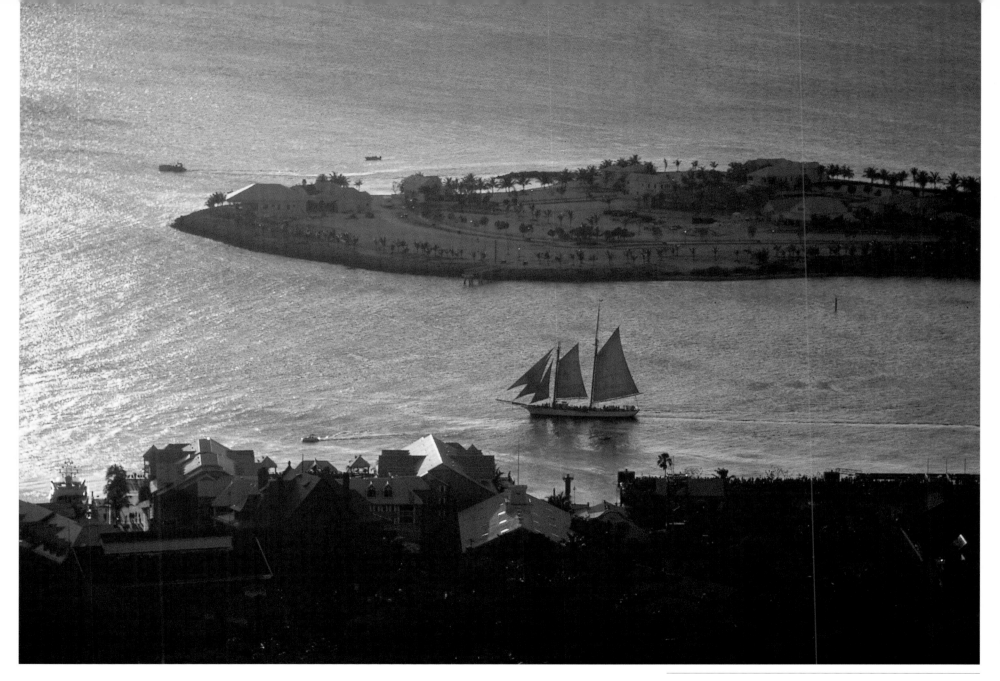

The schooner *Liberty Clipper* quietly slips out of Key West harbor, treating its passengers to an unlimited vista of another celebrated sunset. It is the lull between the hustle and bustle of the day and the fever and excitement of the nightlife.

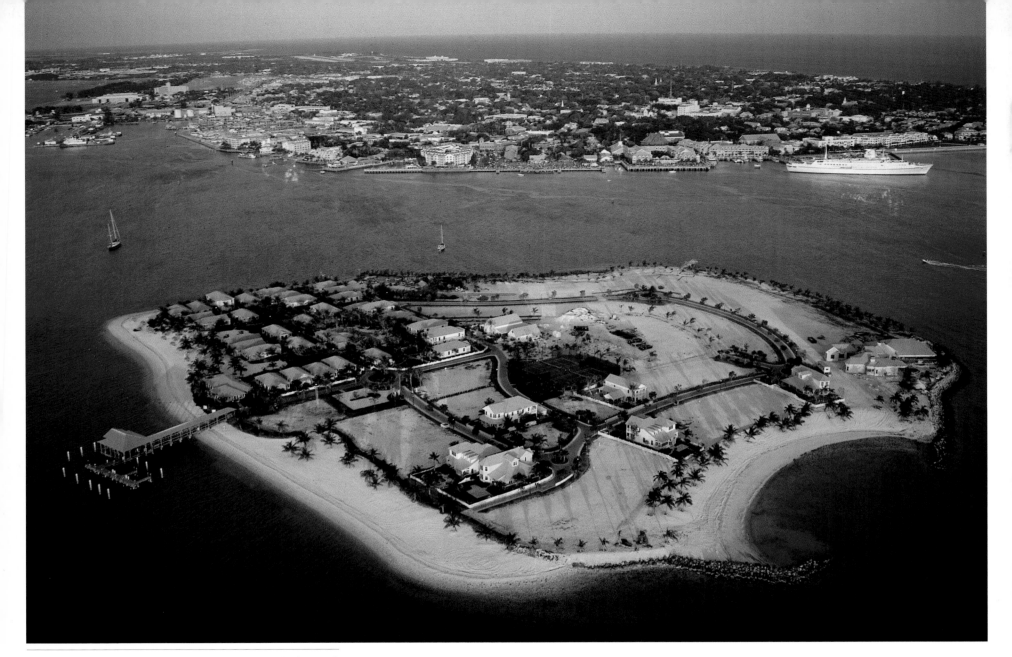

Sunset Key, a stone's throw from Mallory Square in the heart of "old town" Key West, is an island of luxury homes accessible only by boat. Formerly, it was a spoil island, the site of U.S. Navy oil storage tanks. My hover offers the best view of this tranquil piece of expensive real estate.

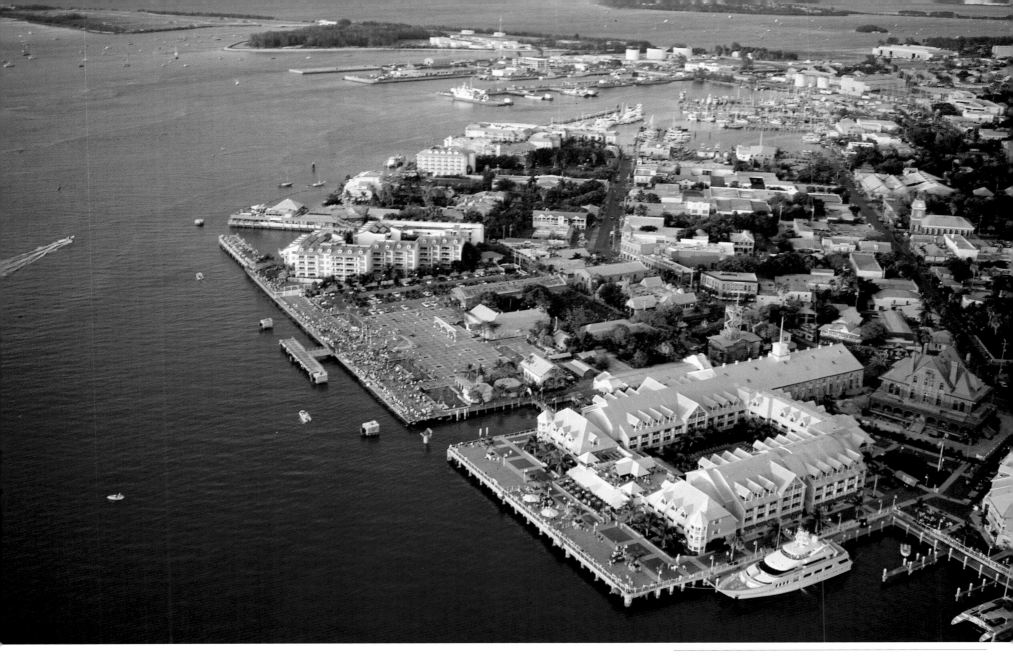

"Sunset Celebration" is what Mallory Dock is all about, replete with arts and crafts exhibitors, street performers, food carts, psychics, and, of course, the thousands of tourists from around the world who visit this Key West happening.

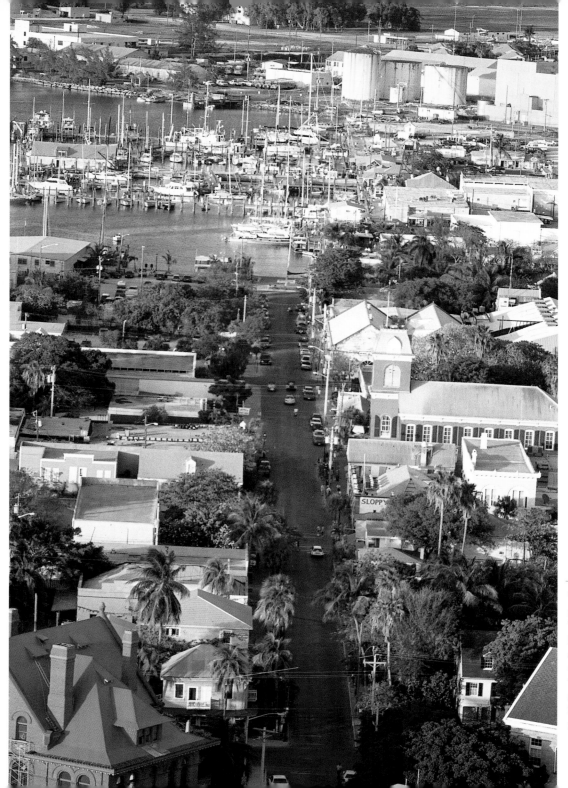

There is no uptown or downtown in Key West. Victorian mansions are next door to restored cigar-makers' cottages. Tolerance of lifestyles is the rule for this eclectic mix of tourist industry workers, government employees, military personnel, artists, writers, and fishermen. This shot is looking down Greene Street from the Customs House. A portion of the Key West Bight, now called the Historic Key West Seaport, can be seen with pleasure yachts at their berths. The Bight was once home to the Key West shrimping, sponging, fishing, and turtle-processing industries.

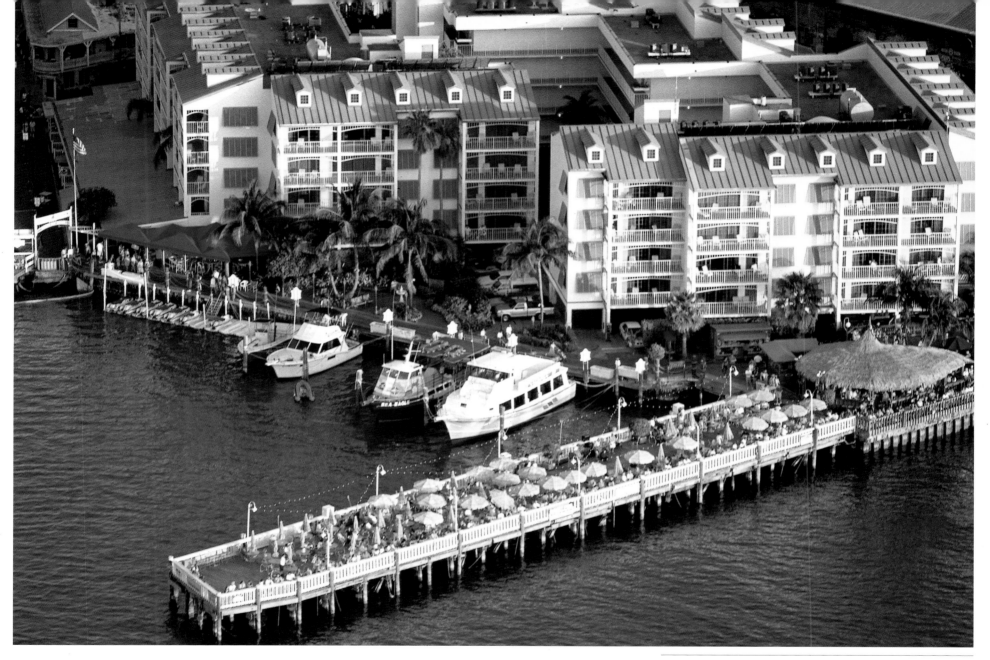

Margaritas, chips and salsa, and a hangout for killer sunsets are part of the manifesto of the Conch Republic. Here we see diners under umbrellas on the pier partaking of that ritual. The hotel is the Ocean Key House, one of the many resort hotels that line the Key West waterfront.

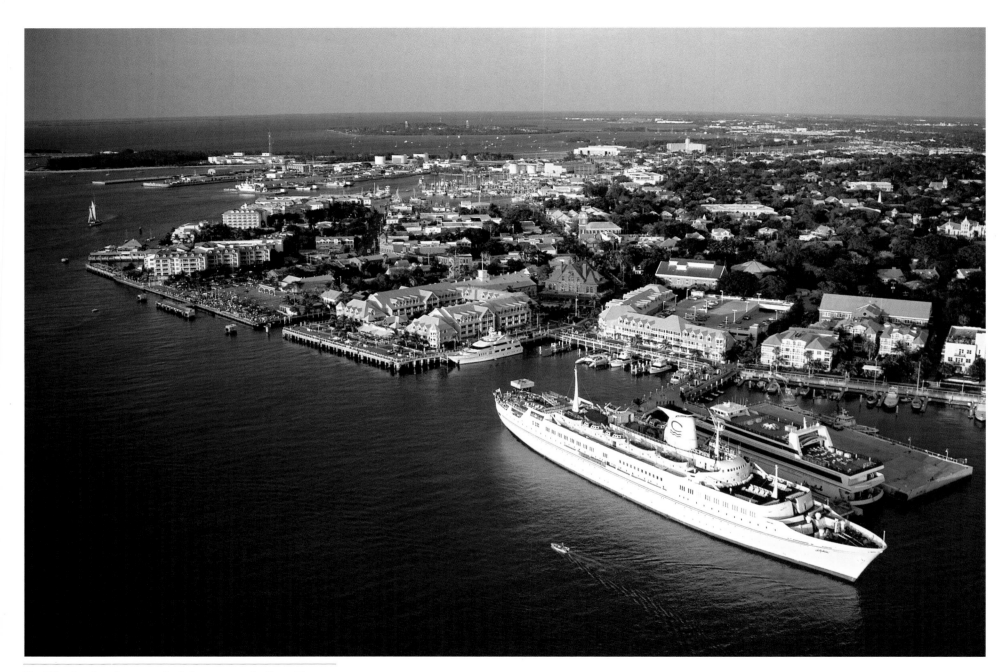

Key West is a favorite port of call for many cruise lines. Here
we see a small cruise ship moored alongside a downtown dock
while a larger one is under way, heading out to sea.

16

Pleasure yachts anchored in a deep channel—some come and never leave again. Because of the shortage of affordable housing, there are many live-aboards anchored in Key West harbor.

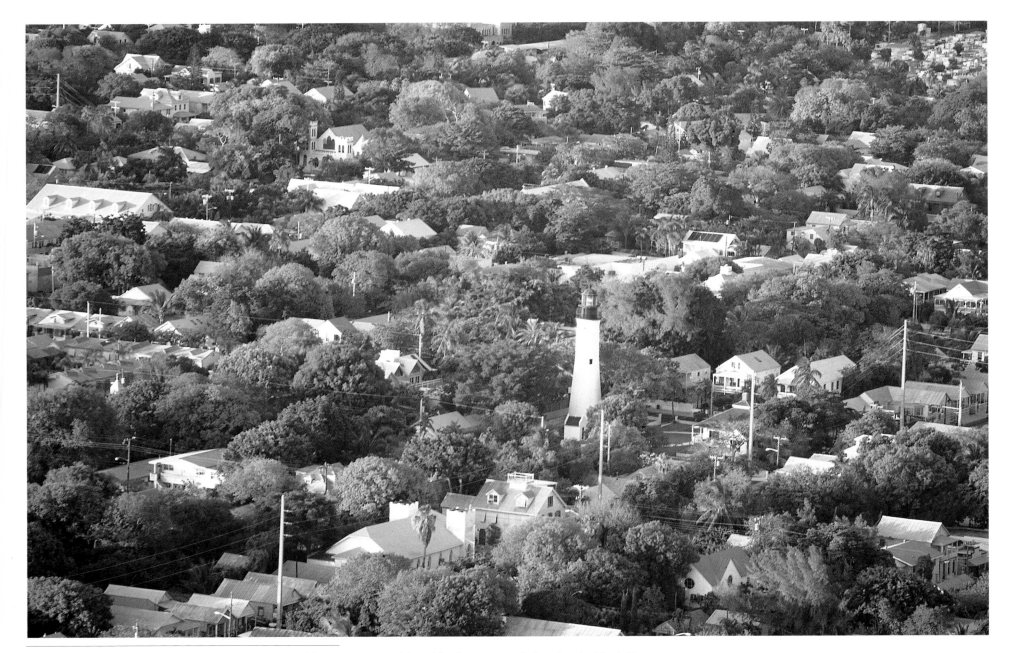

Once it stood as a lone sentinel at the southernmost tip of the U.S., warning ships of the dangerous reefs that ring the island. Key West lighthouse has now passed into the hands of the Key West Art and Historical Society. Completed in 1848 after its predecessor was destroyed in a hurricane, the tower was originally fifty feet high and powered by fifteen oil lamps. It is thought to be farther inland than any other American lighthouse due to landfill that has created real estate seaward of the light. ☀

BIG PINE AND THE LOWER KEYS
Community and Wildlife

If Key West is for the cosmopolitan set, then the Big Pine–Lower Keys area is for lovers of nature and tranquility. It is primarily a residential community for retired people and workers who commute to Key West or Marathon.

Set in a natural environment found nowhere else in the continental U.S., the Big Pine–Lower Keys area features large tracts of undeveloped land covered with mangrove swamps and hardwood uplands. Among the many tropical and semitropical trees that grow there are mahogany, pigeon plum, poisonwood, manchineel (also poisonous), gumbo limbo, wild tamarind, and silver palm.

Big Pine Key is the headquarters of the National Key Deer Refuge, home to the miniature Key deer. Thanks to conservation efforts, the population of this endangered species has grown from a low of fifty to more than three hundred. Also in the area is the Great White Heron National Wildlife Refuge, which offers protection to these majestic wading birds as well as many other rare species.

Four and a half miles south of Big Pine Key is Looe Key Reef, a very popular dive site featuring the most spectacular spur-and-groove coral formations along the Florida Reef. In 1981 it was designated a national marine sanctuary, and in 1990 it became part of the Florida Keys National Marine Sanctuary, which encompasses all the waters surrounding the Keys to protect their fragile marine ecosystems.

Two tethered blimps can be seen in the sky over Cudjoe Key. One is used by the Air Defense Command to monitor aircraft and surface craft traffic in the Straits of Florida. The other is used to broadcast TV programs (TV Marti) to Cuba.

Not to be outdone by Key West in the eccentric category is the Perky Bat Tower on Sugarloaf Key. Constructed by real estate salesman Richter Perky in 1929, it stands as a failed monument to ingenuity. Perky had built a private vacation retreat in the wicked mosquito territory. He erected the tower to house a flock of bats, which he hoped would devour the pests. Unfortunately, the bait that was supposed to attract the bats failed to do so.

I often refer to *Rooty* as a "mosquito on hormones" and find that any flying creature usually heads in the opposite direction when it hears us coming.

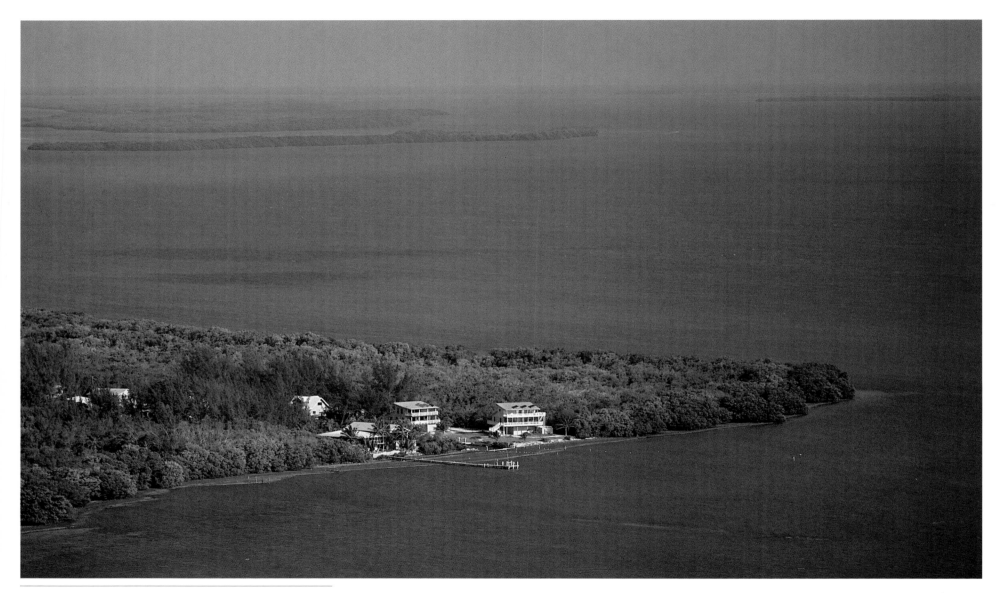

A community of homes on No Name Key. Although the island can be reached by car, there is no electricity, so homeowners depend on solar power and electric generators. The island was home to forty-five Bahamian settlers in 1870, more residents than were there in 1990. When the first Overseas Highway was completed in 1928, there was a ferry landing on the eastern shore where cars embarked for a forty-mile, over-water ride to Grassy Key.

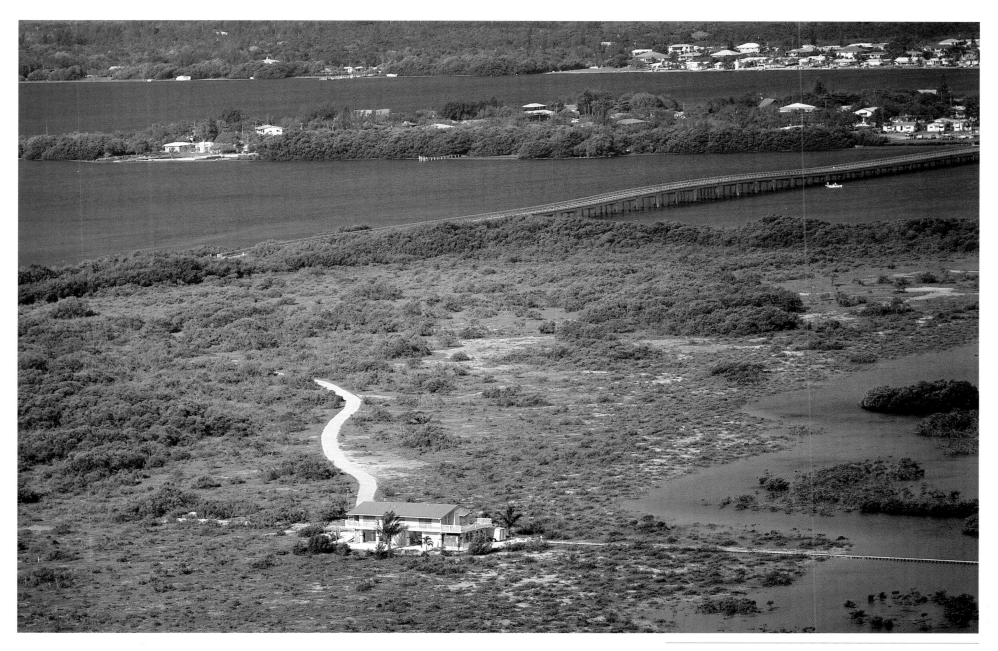

A lone seasonal home occupies a sequestered location on No Name Key. The bridge from Big Pine Key to No Name Key that appears in the background was originally a wooden bridge until it was destroyed by a hurricane in 1948.

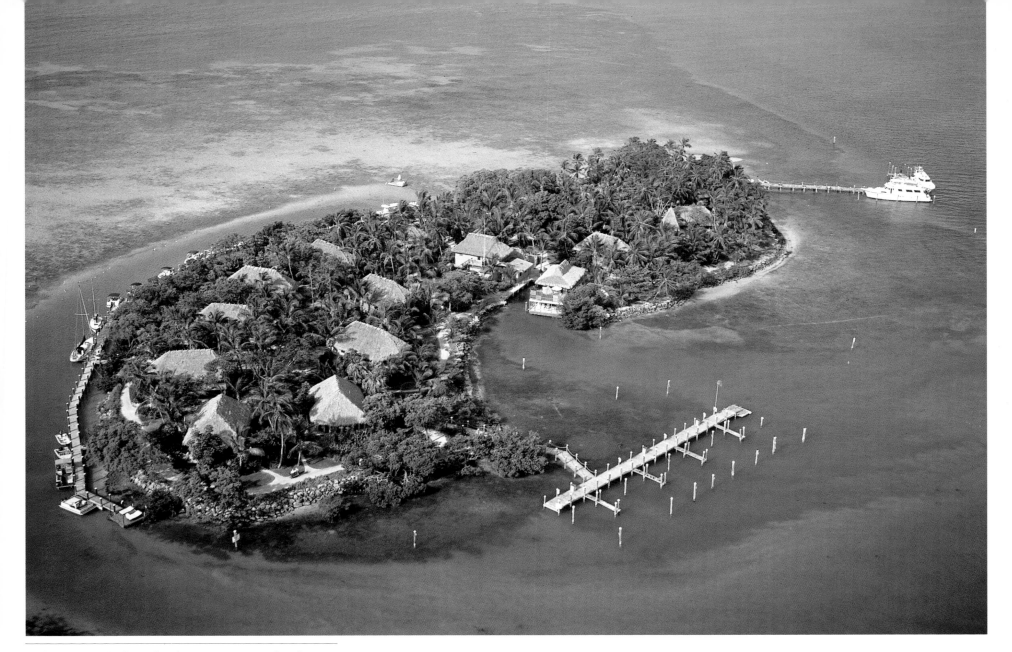

Little Palm Island is located at the entrance to Newfound Harbor, about one and a half miles south of Ramrod Key. Once a private fishing camp, it was visited by Presidents Roosevelt, Truman, Kennedy, and Nixon. Since 1988, it has been a private luxury resort and is hailed as one of the finest vacation resorts in the world.

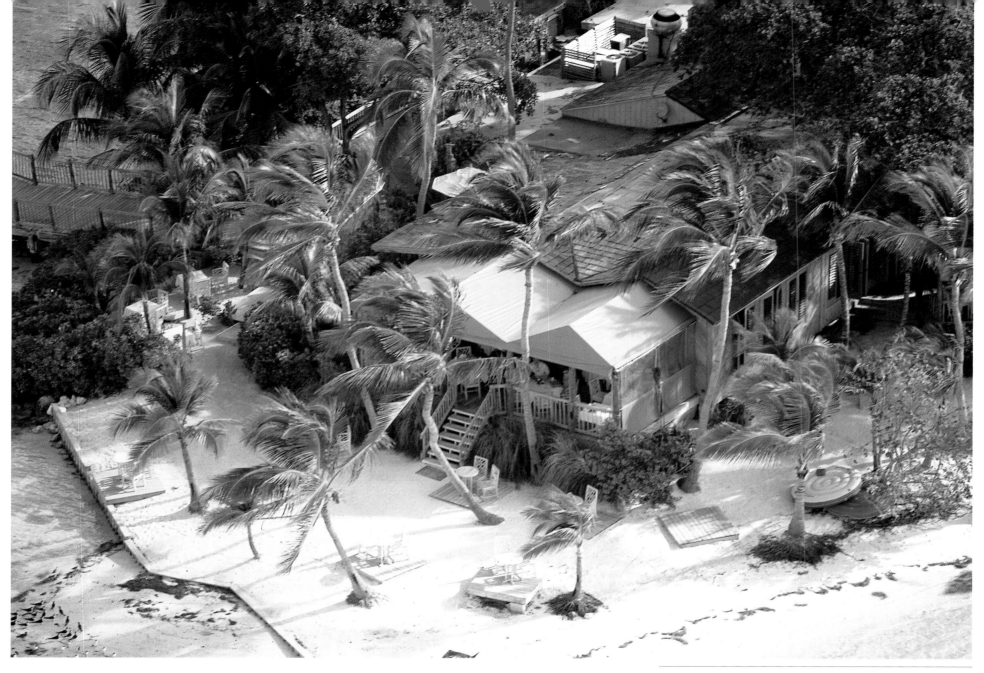

Little Palm Island dining room, where gourmet meals are served and price is no object. In 1960, Warner Brothers Studios selected the island for its South Seas ambiance when filming the movie *PT 109*, based on President Kennedy's wartime experiences.

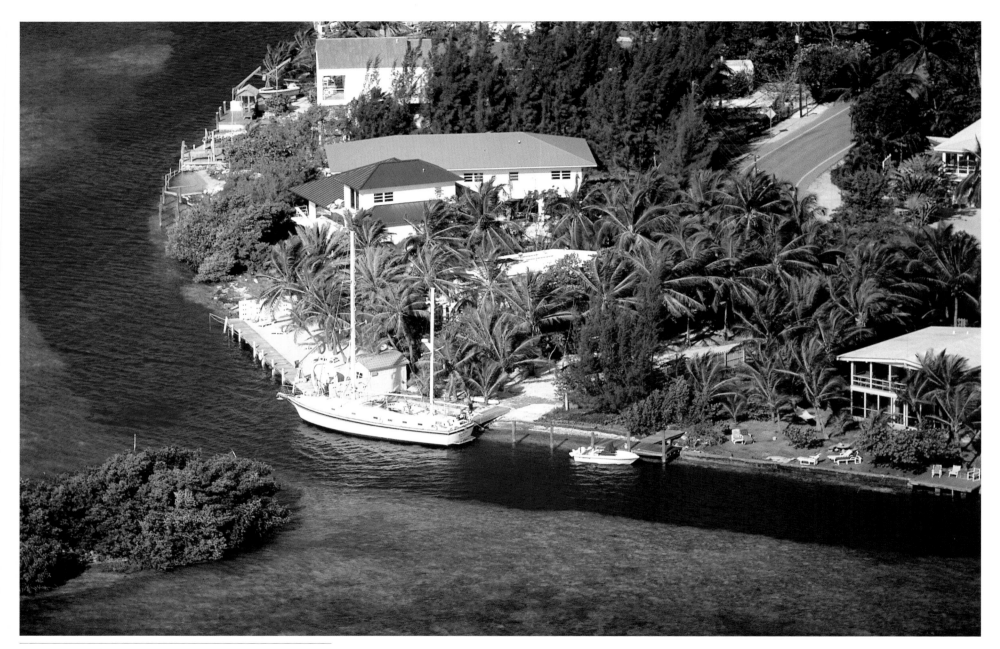

A Lower Keys residential development with a homeowner's sail-
boat moored in the dredged canal. Fill from dredging was used
to build up low-lying land prior to building. Dredging is no
longer permitted.

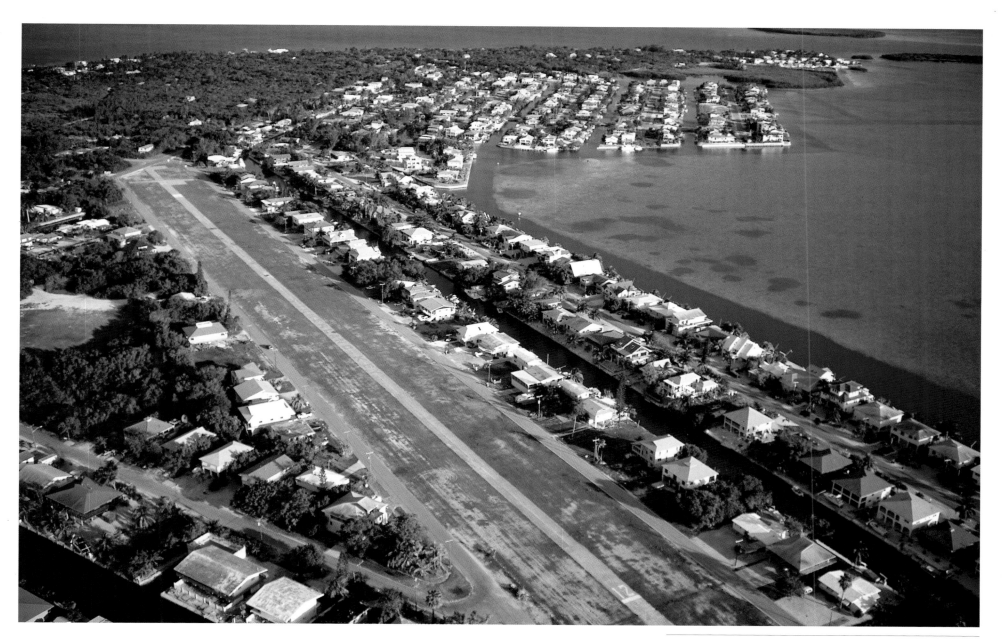

Summerland Key Cove, a community on the ocean side between Cudjoe Key and Ramrod Key along the Overseas Highway, offers residents their own private air strip. After land-ing, the pilot taxis his aircraft under his home, steps into his boat tied in the canal behind the house, and is off for a day's fishing.

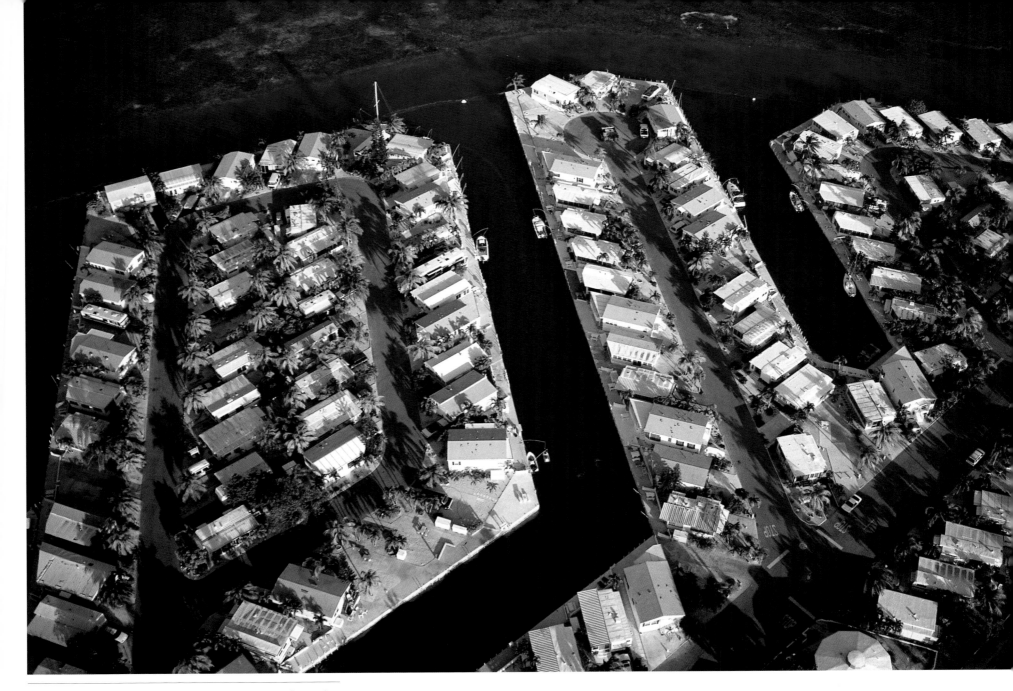

Venture Out, an upscale condominium park for manufactured homes and recreational vehicles on Cudjoe Key. Dredged canals provide waterfront property for its many residents.

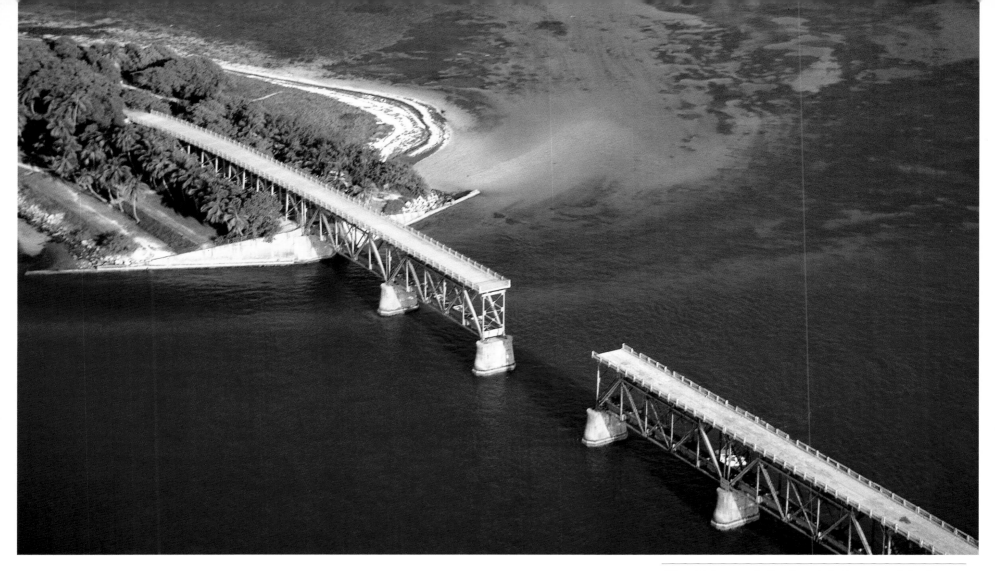

The old Overseas Railroad trestle bridge spanned the deep-water gap between the Spanish Harbor Keys and Bahia Honda Key. After the railroad died in the hurricane of 1935, engineers constructed a two-lane roadway over the top of the bridge (the bridge was too narrow to build it along the railroad level). Today, a four-lane highway bridge bypasses the railroad bridge. A section of the old bridge has been cut away to allow larger boats access to Bahia Honda State Park.

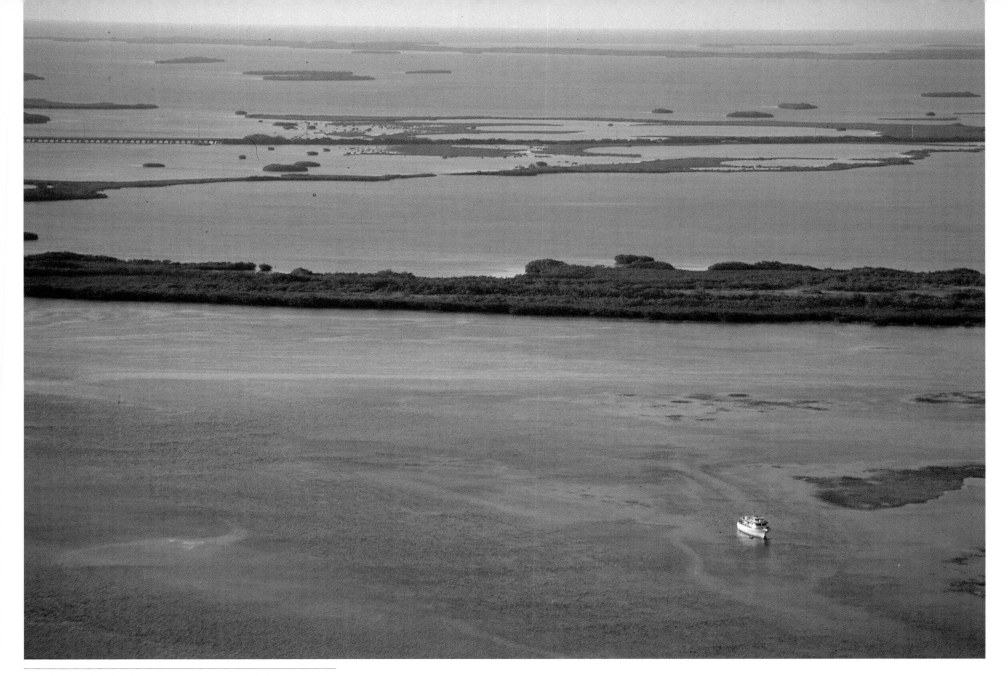

The Lower Keys "back country," a vast area of shallow water on the Gulf side, dotted with hundreds of deserted islands. It is a mecca for flats fishermen, bird watchers, shell collectors, and seekers of peace and tranquility. ☀

MARATHON AND THE MIDDLE KEYS

Heart of the Keys

Located approximately halfway between Key West and Key Largo, Marathon and the Middle Keys are known as the "heart of the Keys." *Rooty* and I set up camp at the Marathon Airport. Rob and Debbie Grant of Grant Aviation were gracious hosts, providing a hangar for *Rooty* and a place to park my camper while I photographed the area.

Knight Key at the western end of Key Vaca (home of the city of Marathon) was the site of a short-lived wrecking settlement beginning in 1822. Around 1830, a small settlement of Bahamian farmers, fishermen, and wreckers sprang up on the eastern end of Key Vaca, but nearly all the settlers left after a Seminole war party raided Indian Key in 1840. The next population boom in the Middle Keys came with the construction of the Overseas Railroad beginning in 1904. Marathon was the headquarters of the giant engineering project, with as many as 1,500 workers in the area from time to time. From 1908 to 1912, while the tracks were being extended to Key West, scheduled train service ran to a dock at Knight Key to connect with steamship service to Havana.

Sport fishing, boating, and diving are some of the offerings of the Middle Keys. On the ocean side, anglers find the "Marathon West Hump," a raised underwater sea bottom that attracts prized game fish. On the Gulf side, deep channels between the shallows, natural ledges, and wreck sites offer prime locations for divers and fishermen in pursuit of mangrove snapper, cobia, and snook. If you are a sportsman or the high-energy type, this may be the spot to hang your hat!

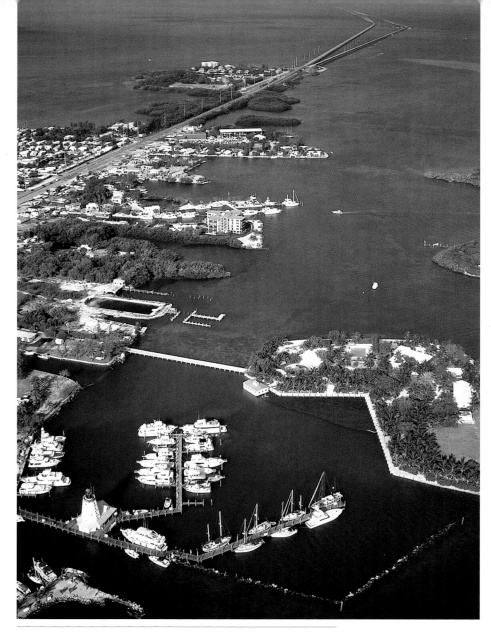

The Gulf side of the western end of Marathon is the site of several marinas and seafood restaurants. The new and old Seven-Mile Bridges can be seen in the distance. Within the white lighthouse at the Faro Blanco Marine Resort (in the lower left-hand corner of the photo), there is a unique two-bedroom hideaway available for rent.

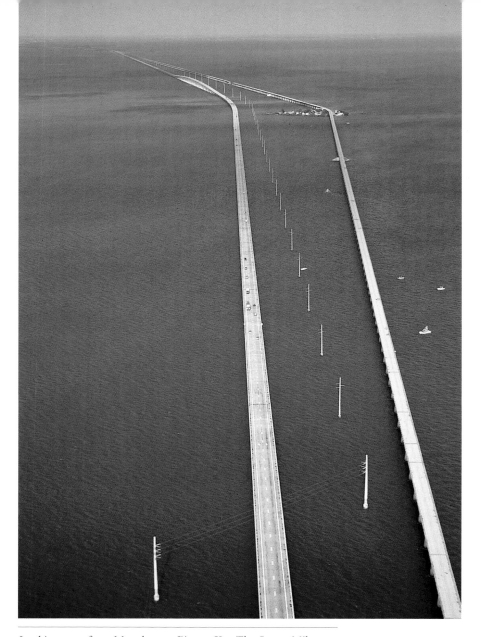

Looking west from Marathon to Pigeon Key. The Seven-Mile Bridge of the Overseas Highway (on the left) is the longest segmental bridge in the world. The bridge on the right is where the old highway and former Overseas Railroad of Henry Flagler once transported passengers and freight to Key West. Damage from the hurricane of 1935, plus failing revenues, led to the abandonment of the railroad after the storm.

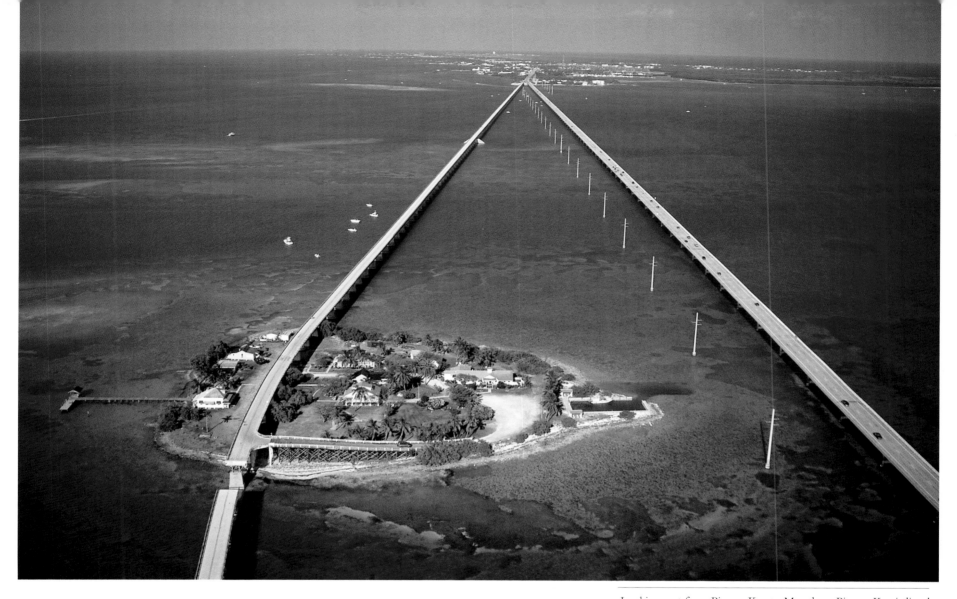

Looking east from Pigeon Key to Marathon. Pigeon Key is listed on the National Register of Historic Places. The five-acre island served as living quarters for more than 400 railroad workers engaged in constructing railroad facilities on Key Vaca and building the Seven-Mile Bridge. The railroad cost more than $30 million and took from 2,000 to 3,000 laborers eight years of brutally hard work to build the bridges and lay the tracks over 128 miles and thirty-six islands. The right-of-way and bridges became the foundation for a new Overseas Highway after the railroad was abandoned following the hurricane of 1935.

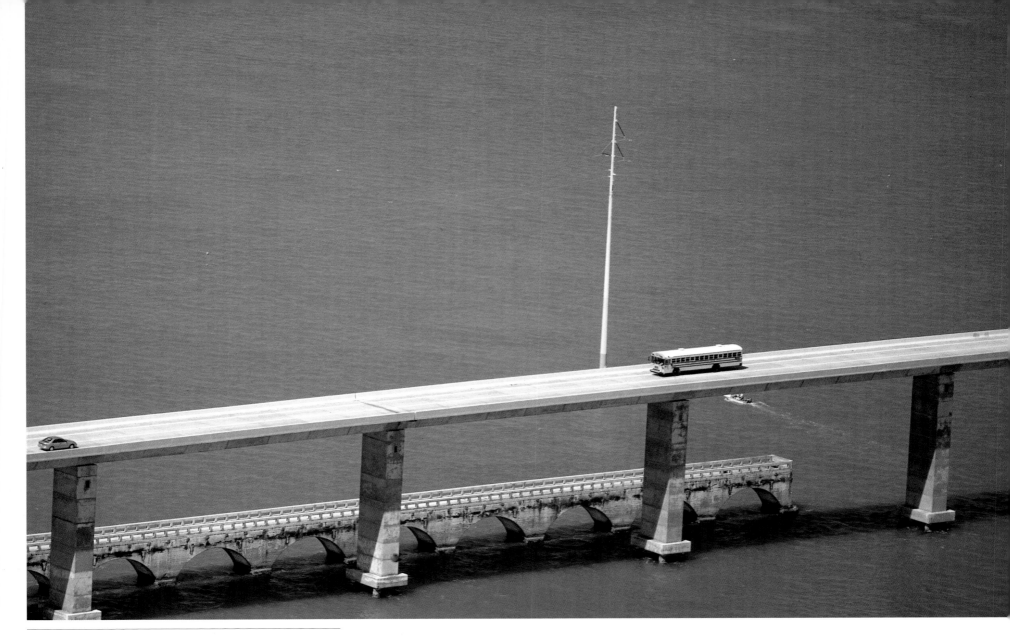

The new Seven-Mile Bridge opened in 1982. The center span shown in the photograph rises sixty-five feet above Moser Channel to permit larger vessels and sailboats to transit between Hawk Channel on the ocean side and Florida Bay on the Gulf side. The old bridge provides access to Pigeon Key and is used by anglers, walkers, and nature lovers to enjoy one of the Florida Keys' most scenic and historic treasures.

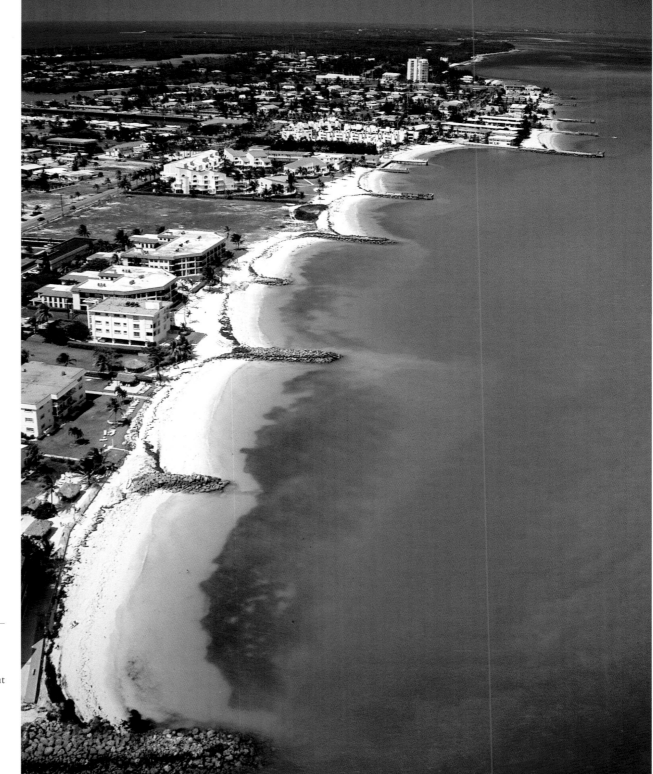

Incorporated in 1957, the city of Key Colony Beach lies on a 285-acre, man-made island dredged out of mangrove swampland located immediately east of Marathon on the ocean side. Connected to the Overseas Highway by a causeway, it has about 800 full-time residents in single-family homes, duplexes, and condominium apartments as well as time-share complexes, a marina, a motel, a beautiful beach, and a par-3 golf course.

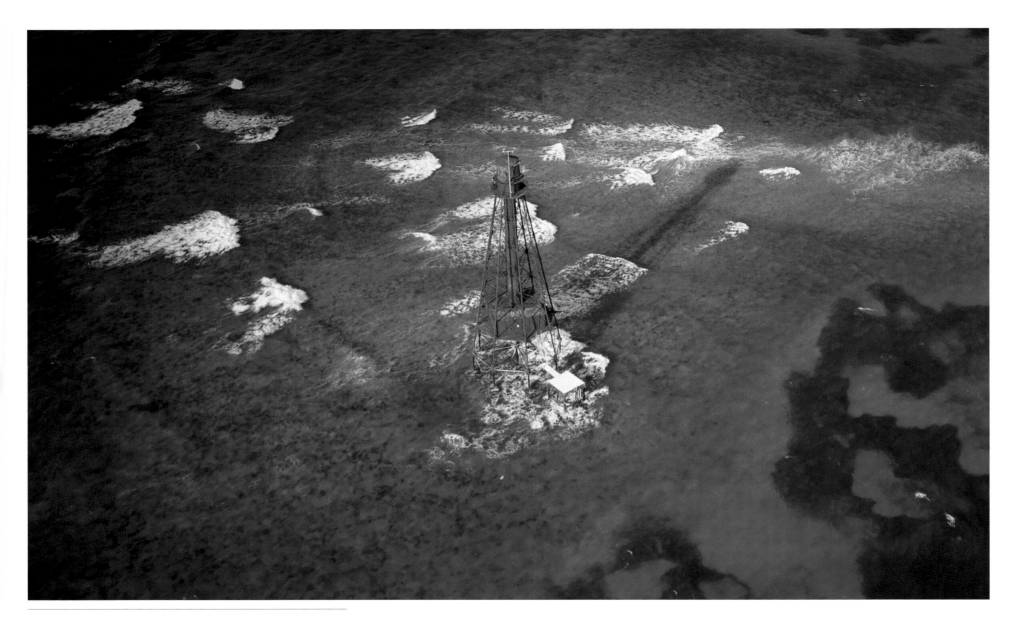

Sombrero Key Lighthouse, completed in 1858, is the tallest of the
reef lighthouses at 160 feet. Located on the reef off Marathon, it is
one of six wrought-iron, screw-pile lighthouses built along the
reef between 1827 and 1880. The advent of these lights did much
to improve the safety of navigation along the Florida Keys and
helped to pave the way for the demise of the wreck-salvaging
industry, once the mainstay of the Key West economy.

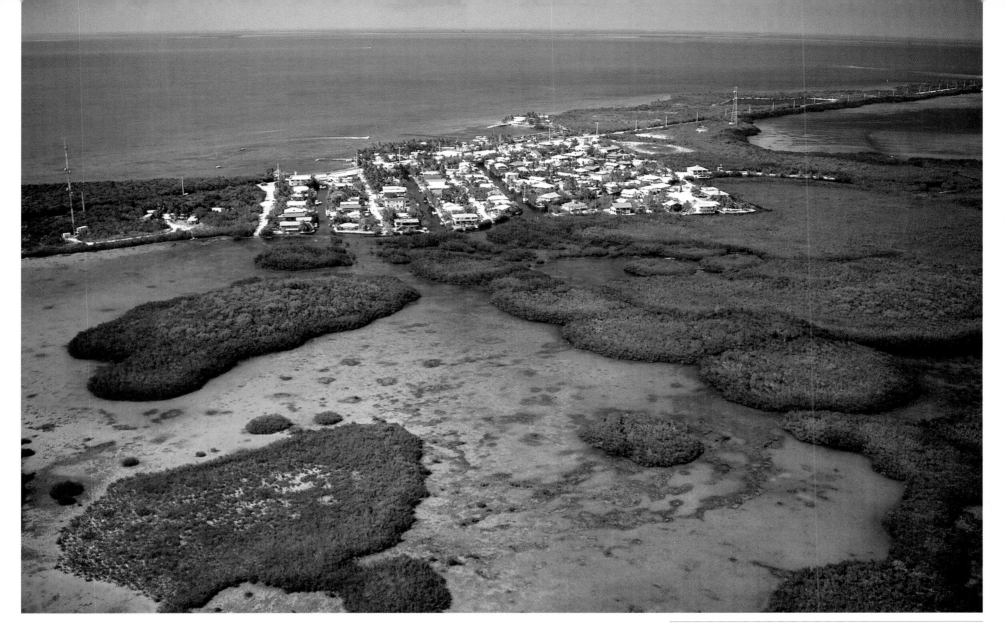

Duck Key is located between Grassy Key and Long Key at Mile Marker 61. In the late 1820s and early 1830s, investors from Charleston, South Carolina, financed the construction of salt ponds for the manufacture of salt from sea water, but poor profits led to the abandonment of the project. Connected by a causeway to US 1, today it is the site of a large resort hotel, marina, and many retirement homes.

This unusual sailing craft, a tri-hull hydrofoil, caught my eye for its design and swiftness through the water. The sheltered waters on the Gulf and Florida Bay side of the Keys make them an ideal playground for boats such as this one.

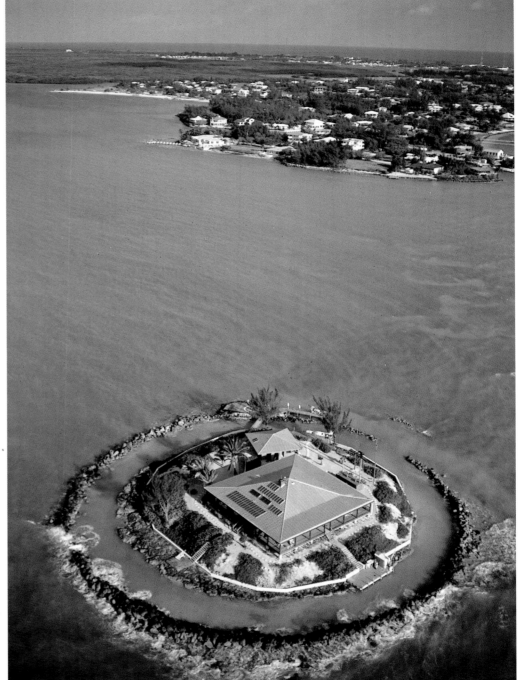

If privacy is your attitude in these latitudes, then this self-sufficient home on East Sister Rock off Marathon on the ocean side might just be your style. It comes with a 360-degree view and a helicopter pad.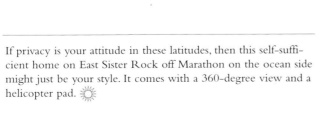

ISLAMORADA AND THE MATECUMBE KEYS
Sport Fishing Capital of the World

This chain of keys stretches from Long Key beginning at Mile Marker 66 to Plantation Key ending at Mile Marker 88. Long Key is the site of the Long Key State Recreation Area. Lower Matecumbe Key is next in line. The terrible Labor Day hurricane of 1935 killed over 400 people on Lower and Upper Matecumbe Keys. Among these were some 250 World War I veterans encamped on Lower Matecumbe and engaged in building a road from Lower Matecumbe Key to Grassy Key. Lignumvitae Key, just north of the upper end of Lower Matecumbe, is a state botanical site, and Indian Key to the north is a state historical site.

Upper Matecumbe Key is the headquarters of the recently incorporated village of Islamorada, encompassing the populated keys from Lower Matecumbe Key to Plantation Key. A monument in the center of Upper Matecumbe Key marks the mass burial site of those who died in the 1935 hurricane. Islamorada, "Island Home" in Spanish, is the gathering place for some of the cream-of-the-crop charter boat captains, who have made it the "Sport Fishing Capital of the World."

Windley Key, at a whopping eighteen feet, vies with Lignumvitae Key as the highest spot in the Keys. From the late 1880s to the early 1900s, pineapple plantations on Plantation Key, along with those on Upper Matecumbe and Key Largo, produced bumper crops and record profits. A hurricane in 1906, followed by a blight and competition from cheaper Cuban imports, put an end to the industry.

At low tide you can take your boat a short distance offshore of Upper Matecumbe on the ocean side to the popular meeting spot at the "sandbar," or hang from a parasail and watch the sunset from a lofty perch almost as good as mine. It is definitely at a latitude (and altitude) that will change your attitude.

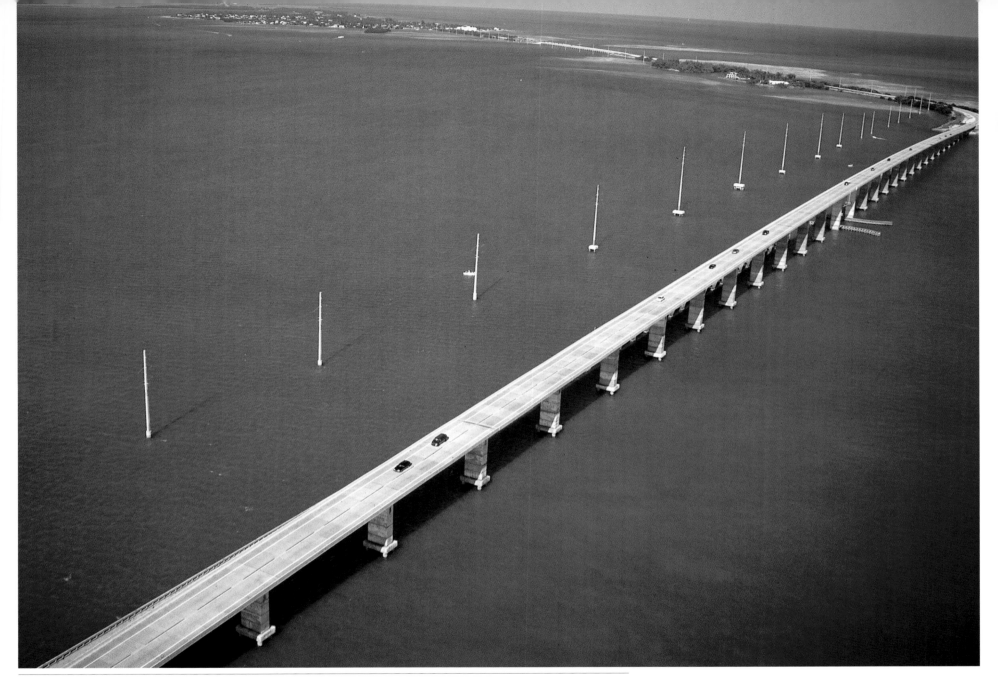

The high-rise bridge at Mile Marker 71 between Fiesta Key and Craig Key has a vertical clearance of sixty-five feet for vessels passing between Hawk Channel on the ocean side and Florida Bay on the Gulf side. Fiesta Key (not shown) was purchased by the Greyhound Bus Lines in 1936, named Greyhound Key, and used as a rest stop for buses running between Miami and Key West until the 1960s. Today, as Fiesta Key, it is a recreational vehicle park and campground.

A woman wades in the shallow waters off Ann's Beach, leaving a cloud of disturbed silt in her wake. The beach is located at the lower end of Lower Matecumbe Key on the ocean side at Mile Marker 73.

Craig Key on the left of the highway, with Lower Matecumbe Key in the distance. Tiny settlements on Craig Key were twice wiped out by hurricanes. The 1935 hurricane destroyed a fish house, marine railway, and fishermen's houses. Hurricane Donna in 1960 destroyed a post office, restaurant, service station, and three houses.

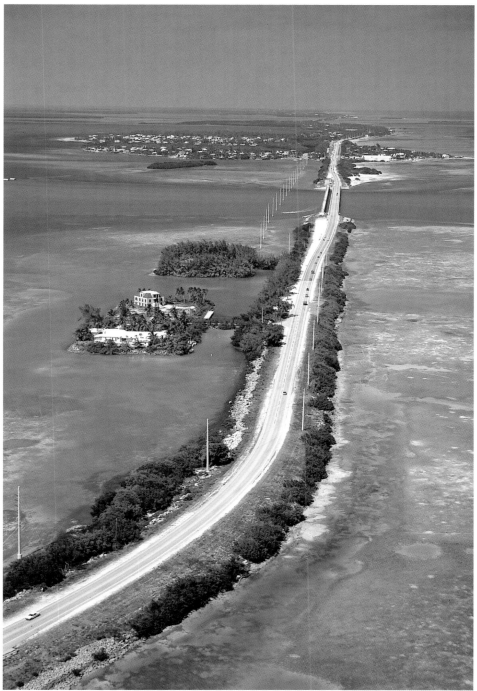

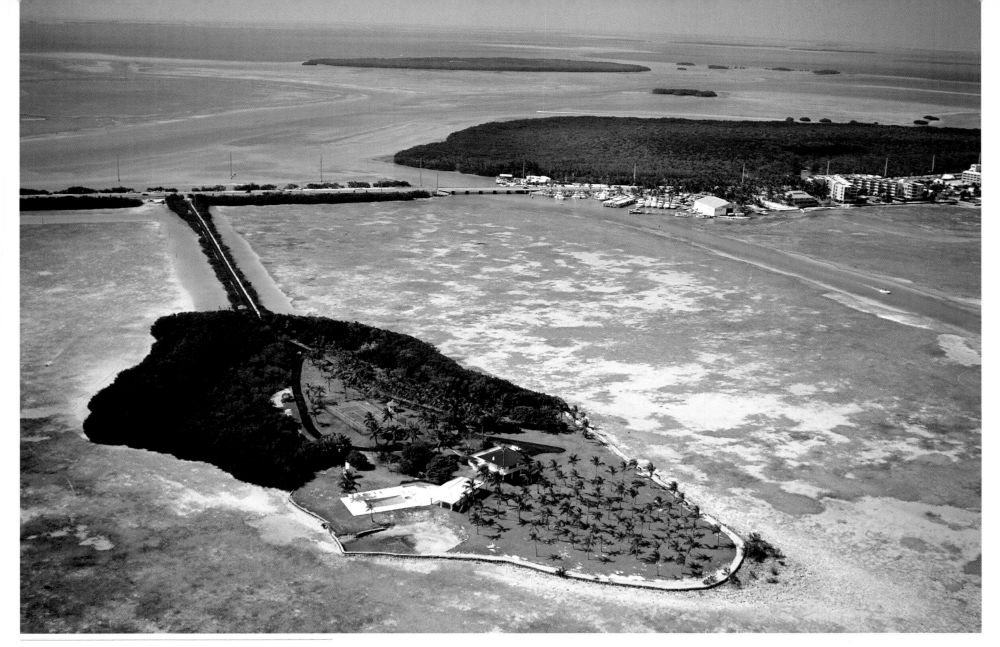

Teatable Key, a half-mile southwest of Upper Matecumbe Key
and connected to the Overseas Highway by a causeway, is
privately owned. During the Second Seminole War (1836–1842),
it served as a base for sailors, marines, and revenue marines
engaged in hunting the elusive Seminole Indians in the Upper
Keys and the Everglades.

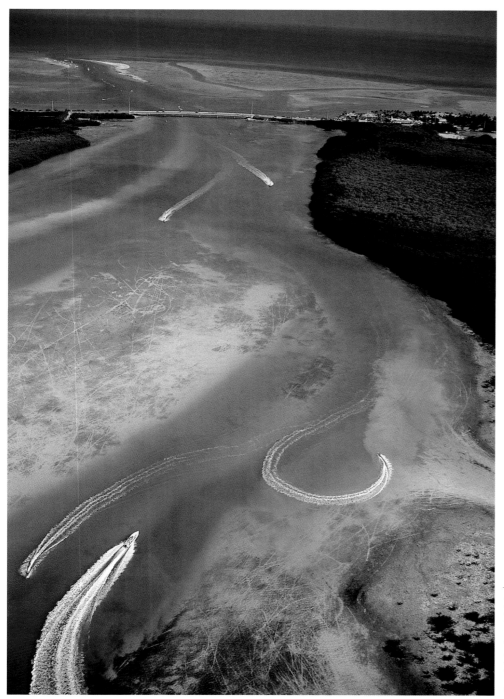

A half-mile off the upper end of Upper Matecumbe Key on the ocean side is a large sandbar that bares at low tide. It is a popular gathering spot for boaters who wish to wade, swim, and socialize.

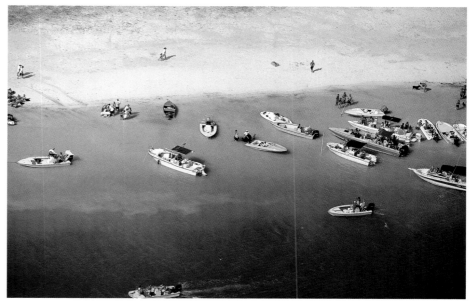

Between Upper Matecumbe and Windley Keys are two popular harbors, Windley Harbor on the Florida Bay side and Whale Harbor Channel on the ocean side. This area is heavily used by boaters, who cross from the more sheltered waters of Florida Bay to the bigger-game fishing grounds on the ocean side. Windley Key was once two keys called the Umbrella Keys until railroad workers filled the gap between them.

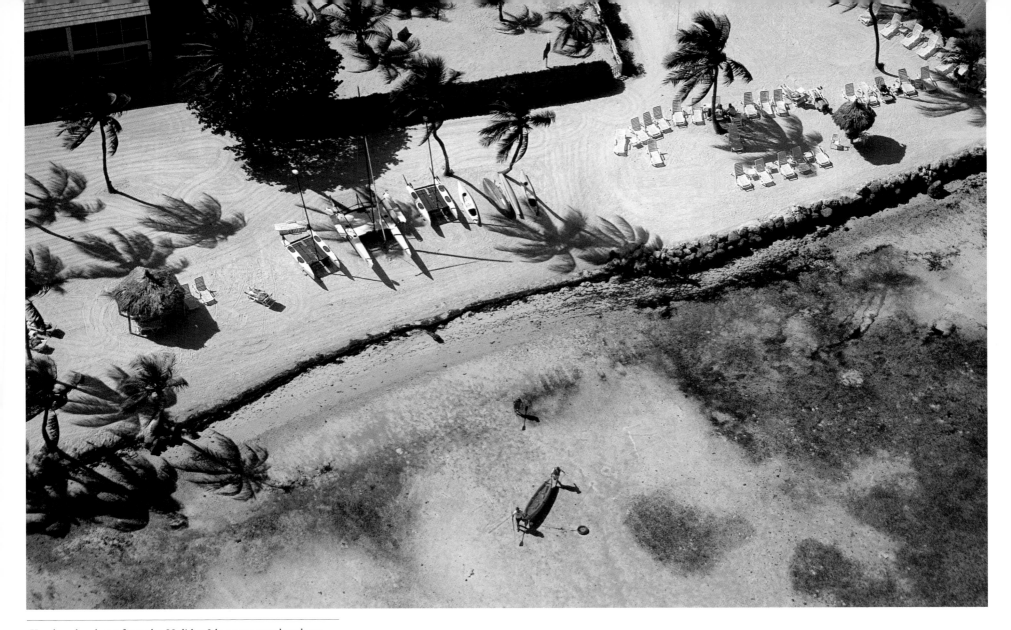

Kayakers head out from the Holiday Isle resort area beach on Windley Key for an afternoon of exploration around the island. The Windley Key quarry is now the Windley Key Fossil Reef State Geological Site. It was quarried during railroad construction to provide fill for the roadbed. The clean cuts made by the quarry machinery revealed fossilized specimens of a variety of ancient coral animals.

42

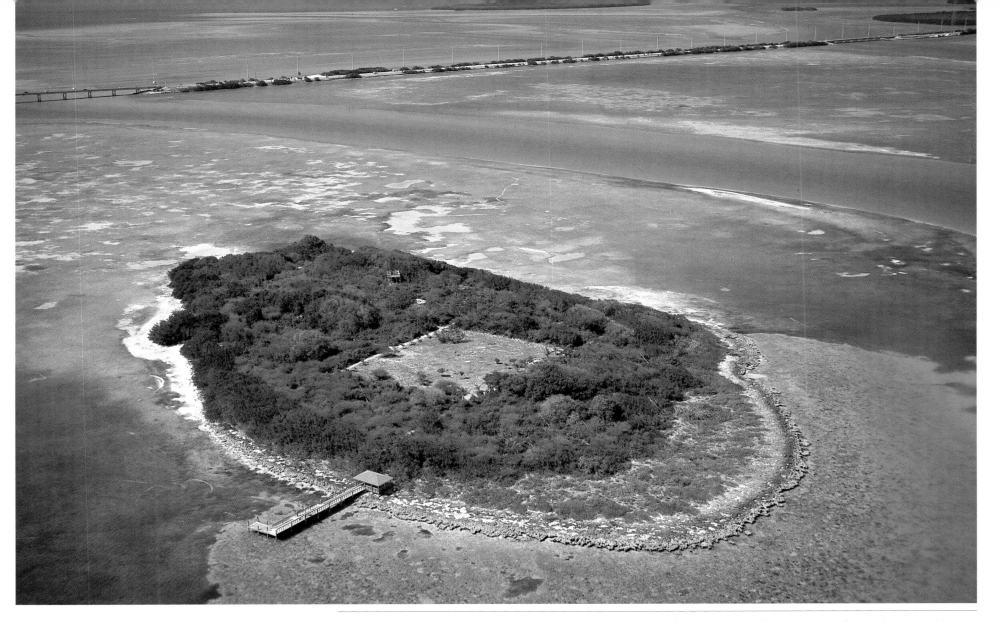

Indian Key, designated a state historic site in 1971, lies about a mile off the upper end of Lower Matecumbe Key. An enterprising wrecking captain opened a store there in 1824 to sell goods to the wrecking vessels that frequented the harbor and to Indians who came down from the mainland to trade. By the early 1830s, it was a thriving wreckers' settlement complete with a hotel, a bowling alley, and a warehouse to store salvaged cargoes under the leadership of an unscrupulous wrecking captain named Jacob Housman. Using devious methods, Housman built up a small fortune from his wrecking operations and made the island into a tropical paradise. All this came to an end when, in August 1840, a war party of over one hundred Seminole Indians raided the island, killed six of the inhabitants, looted the store, and burned nearly every building to the ground. Visitors may reach the island by private boat or tour boats and take a walking tour to view the remains of building foundations, cisterns, and streets.

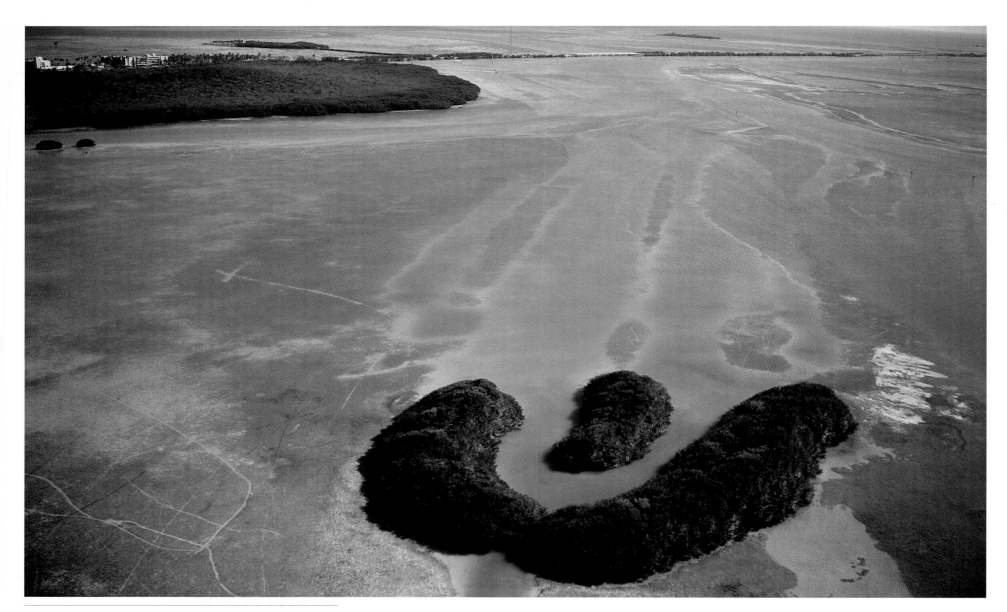

Looking like an open clam shell, unoccupied Shell Key is about a mile to the north of the lower end of Upper Matecumbe Key in Florida Bay. Florida Bay is nearly 1,000 square miles of shallow water, seagrass beds, and small unoccupied mangrove islands lying between the southern shore of the Everglades and the Upper and Middle Keys. It is important as a nursery ground for fish, shellfish, shrimp, spiny lobsters, and turtles.

44

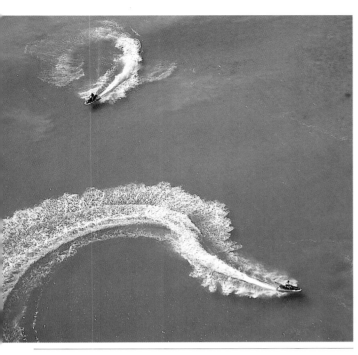

I find personal water craft annoying, but they are popular rental craft at the Holiday Isle Beach Resort on Windley Key. Just beyond the resort is the Theater of the Sea, where visitors can see dolphins, sea lions, sea turtles, sharks, stingrays, and other denizens of the reef in a saltwater lagoon.

Careless water craft have scored the surface of this shallow area off the exit from Whale Harbor Channel between Upper Matecumbe Key and Windley Key. Prop-dredging, as such scoring is called, has caused extensive damage to seagrass beds throughout the Keys. Seagrass beds are spawning grounds for hundreds of species of Florida Keys sea life.

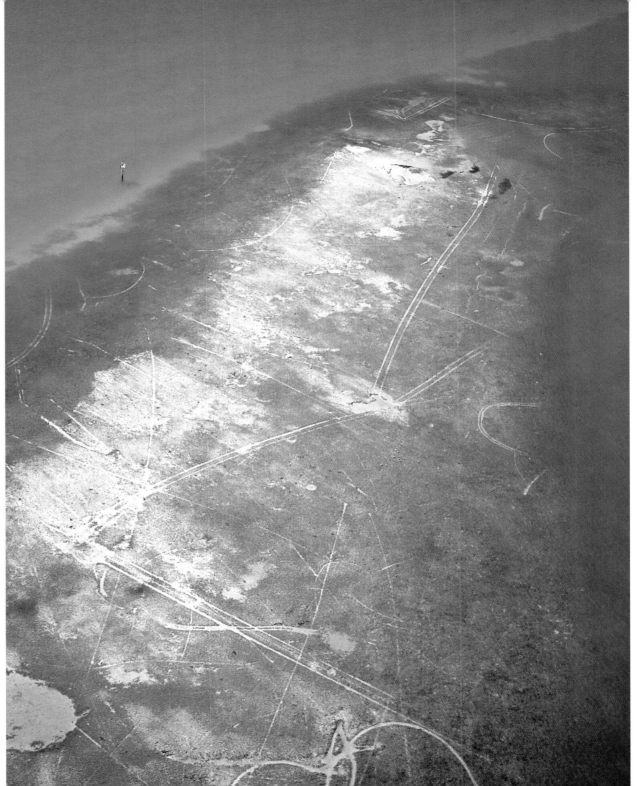

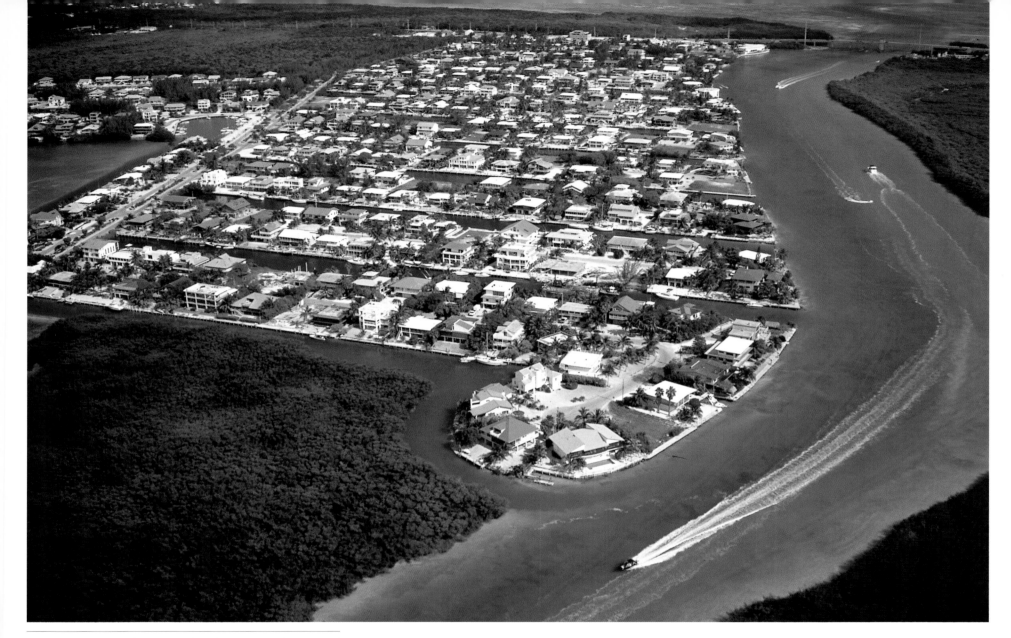

Snake Creek, a natural waterway, slices between Windley Key and Plantation Key. The Bay View Isles residential development tenuously hangs onto land built up on fill from the dredged canals. A lift bridge in the Overseas Highway allows larger vessels and sailboats to use the waterway to transit from one side of the Keys to the other.

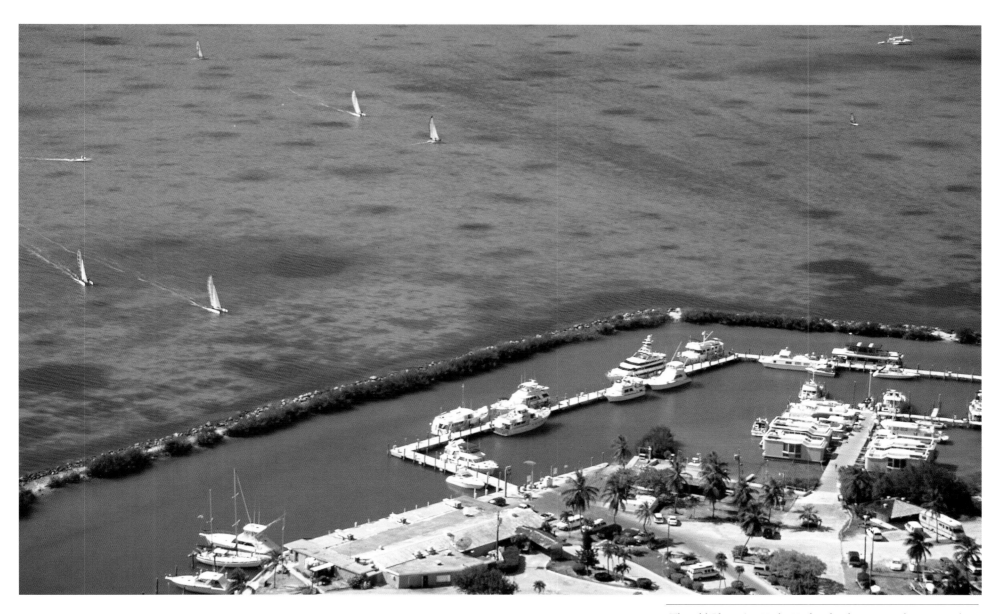

The old Plantation Yacht Harbor has been recently renovated. When this photo was taken, it was my home while photographing the Upper Keys. The shallow, calm waters just on the other side of the breakwater attract smaller sailboats to enjoy an afternoon of racing. Plantation Key is believed to have derived its name from the large pineapple plantations that were an important Upper Keys industry in the late 1800s and early 1900s.

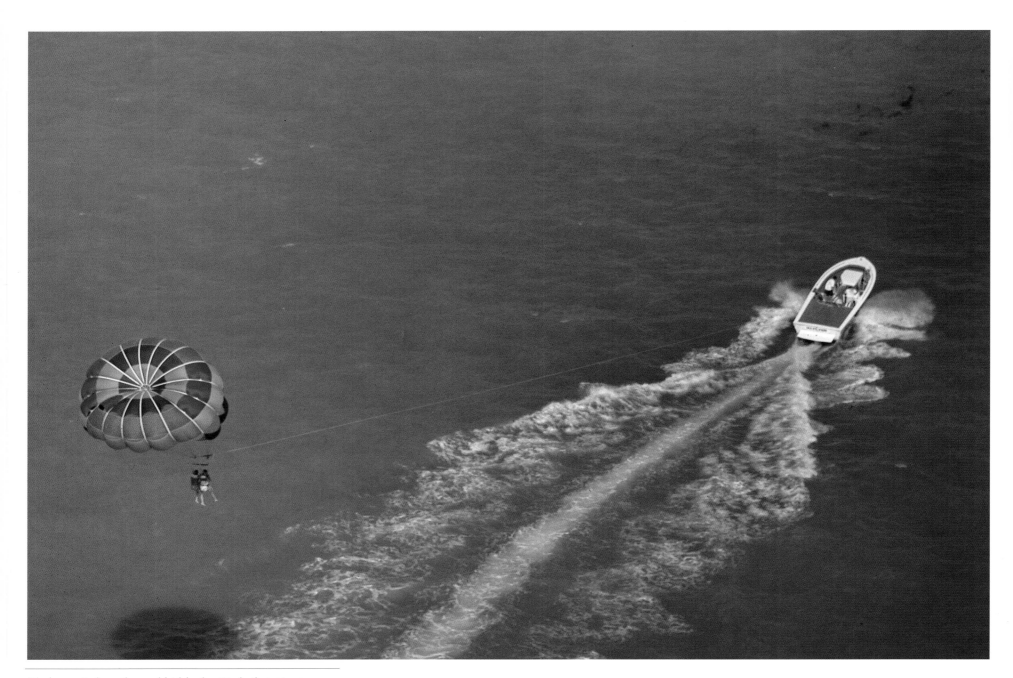

It's the tropical weather and laid-back attitude that attract so many tourists to the Keys, and for the adventuresome there is the opportunity for a parasail ride. ☀

48

KEY LARGO AREA
Diving Capital of the World

Named *Cayo Largo,* or Long Key, by the Spanish, Key Largo, some thirty miles in length, is the largest of the Keys. During the Second Seminole War (1836–1842), Indian war parties from the mainland raided the key. On one occasion, they attacked and burned a wrecking schooner anchored at Tavernier Key. On another, they ambushed and killed the captain and one crewman of the Carysfort lightship as they stepped ashore to gather stovewood.

Old Ben Baker, the most successful of the post–Civil War wrecking captains, started pineapple growing on Key Largo about 1866, but he always kept one eye peeled towards the reef for the chance of sighting a wrecked ship.

After the end of pineapple growing in 1915, Key Largo farmers turned to raising Key limes, tomatoes, and other truck-farm produce. After the completion of the second Overseas Highway in 1938, the tourist industry began to grow.

At Mile Marker 102.5, you come to John Pennekamp Coral Reef State Park, the nation's first underwater state park, encompassing approximately 54,000 acres of underwater area and 2,300 acres of uplands. The park offers snorkeling and scuba diving, as well as glass-bottom boat rides with underwater vistas of coral formations, seagrass nurseries, and shipwrecks. There are also miles of mangrove trails, campgrounds, and protected swimming areas. The park is named for *Miami Herald* journalist John Pennekamp, whose impassioned editorials prodded government and private individuals to take action to preserve the Florida Reef.

If you happen to be in a nostalgic state of mind, you can visit the Caribbean Club, where the movie *Key Largo* was supposedly filmed. Actually, it was filmed on a Hollywood sound stage. Bogart and Bacall never set foot on Key Largo.

I found it hard to resist the temptations of this water-oriented lifestyle, so I kicked off my flying boots and slipped on a pair of fins and a mask for a day of snorkeling in these dazzling waters.

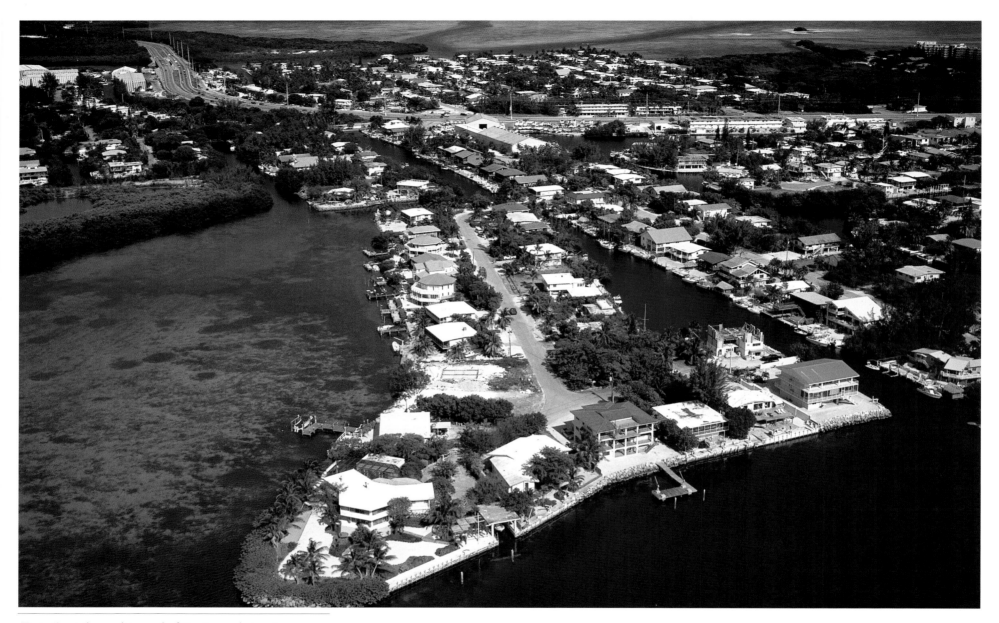

Tavernier, at the southern end of Key Largo, derives its name
from nearby Tavernier Key. This key, once a popular anchorage
for wrecking vessels, was originally named *Cayo Tabona*
("Horsefly Key") by the Spanish. Tavernier may be a linguistic
corruption of *Tabona,* or a French mariner named Tavernier
(tavern keeper) may have left his name there.

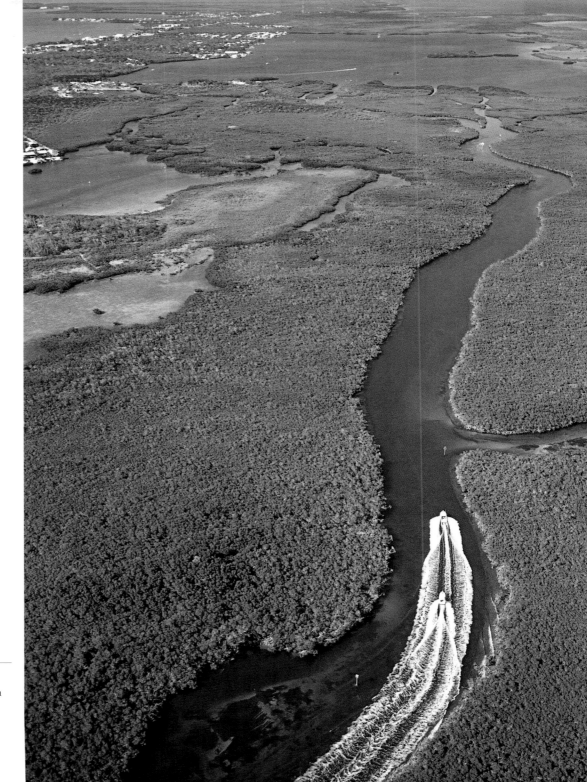

Motorboats speed through the narrow winding creeks in the John Pennekamp Coral Reef State Park. Since this photograph was taken, speeding in the creeks has been prohibited in order to protect the mangroves and wildlife.

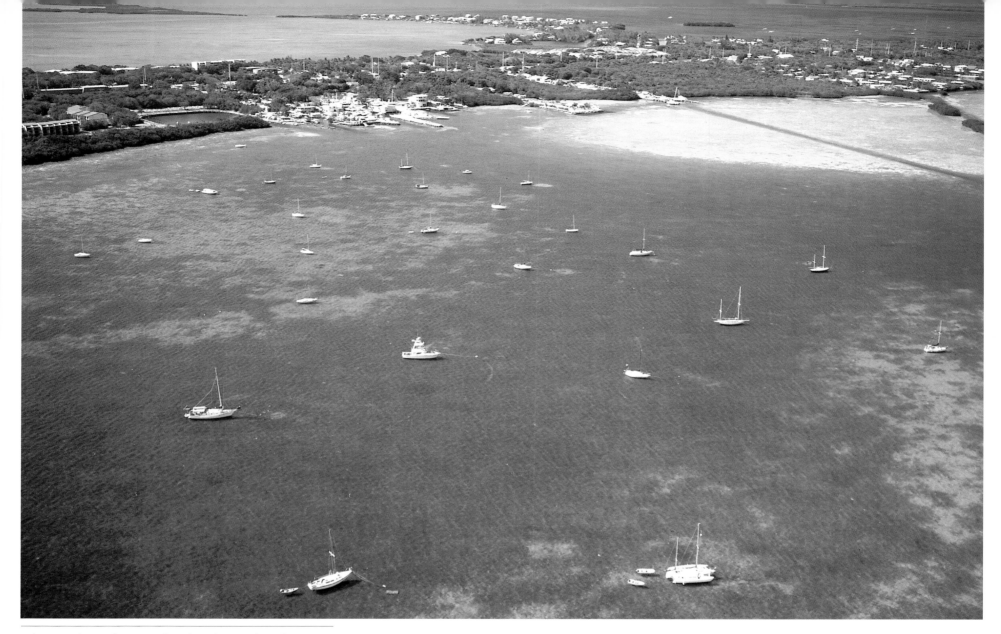

This view shows pleasure craft anchored in Rock Harbor, one of the few well-protected anchorages on the ocean side of the Upper Keys. It was a much-frequented anchorage in the days of the wreckers and a small settlement of farmers and fishermen in the late 1800s. In 1948, local officials persuaded the postal service to change the name of the post office from Rock Harbor to Key Largo in order to capitalize on the movie of the same name.

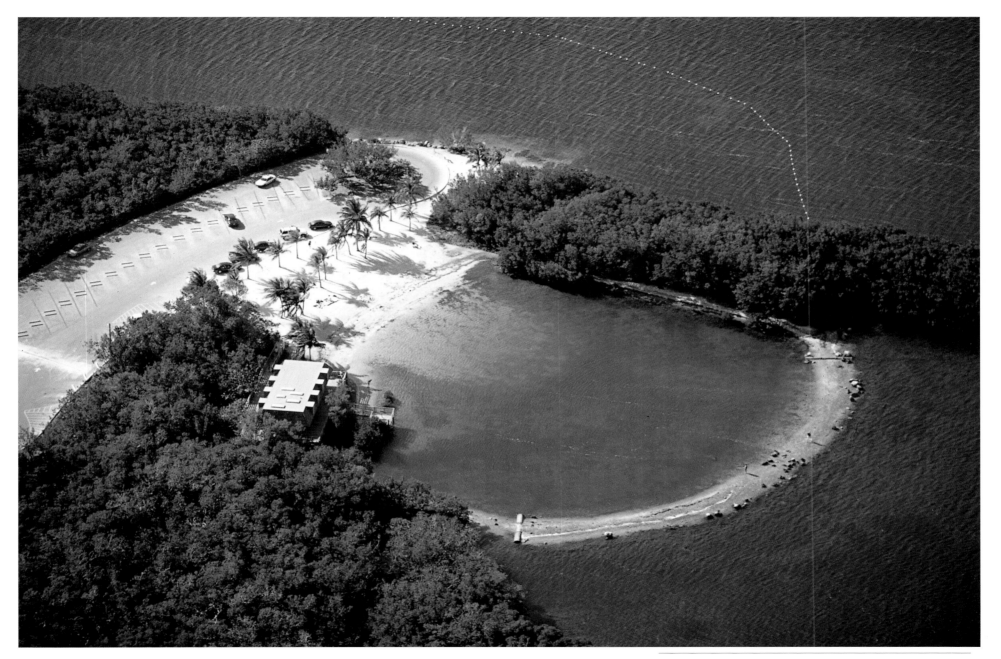

A shallow lagoon at John Pennekamp State Park provides a safe swimming area for children and beginners, while a line of buoys warns boaters to keep their distance from the deep-water beach.

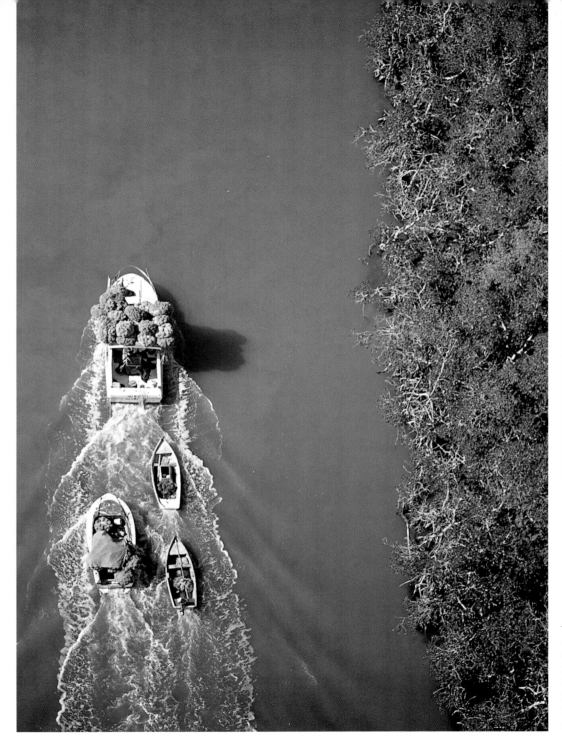

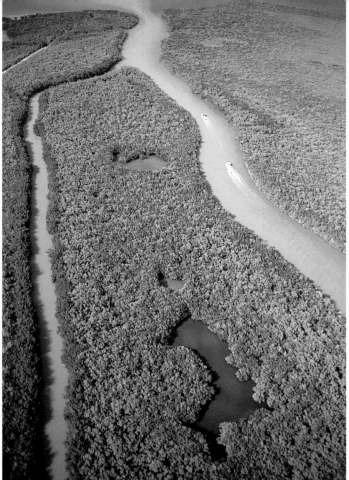

Jewfish Creek is the gateway to the Keys in the protected water-way coming from the north. The waterway passes from Biscayne Bay into Card Sound and Barnes Sound, then through Jewfish Creek into Blackwater Sound. This is where the Everglades Park ends and an enchanting journey through the fabulous Florida Keys begins.

A loaded sponge boat towing sponge dinghies heads north through Jewfish Creek, probably on its way to Miami to sell the haul. Beginning in 1849, sponging gradually grew to become a major industry in the Keys, until the Keys take was outstripped by hard-hat divers operating out of Tarpon Springs in the early 1900s. In 1939, a blight killed most of the Keys sponges, but sponging has resumed on a small scale today. ☀

FLORIDA CITY AND THE EVERGLADES

The Gateway to the Keys

This area has long been known for its fine agricultural products, but lately shops, restaurants, and hotels are sprouting up in what has come to be called the "Gateway to the Keys." Close at hand is the Everglades National Park, the unique area dubbed the "River of Grass" by Marjory Stoneman Douglas in her famous book of the same name. Its million and one half acres encompass sawgrass prairies and mangrove and cypress swamps populated by alligators, crocodiles, deer, panthers, wading birds, and many other species of wildlife. The Everglades is the only place in the world where alligators and crocodiles exist side by side.

Homestead and Florida City were ground zero for the strongest winds of Hurricane Andrew in 1992. You can still see remnants of the destruction, though most of the area has recovered.

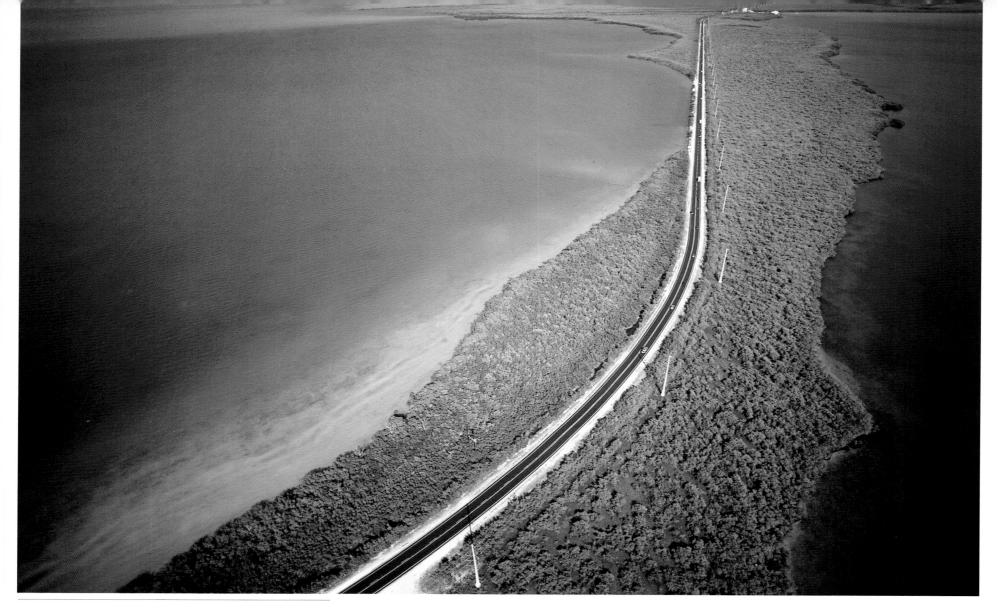

A section of the eighteen-mile highway that connects mainland
Florida City with Key Largo. The water on the left is Barnes
Sound and on the right Blackwater Sound. The stretch is the
subject of a struggle—between residents of the Upper Keys, who
want to limit traffic to the Keys, and state highway officials, who
want to reduce accidents—as to whether or not to make it a
four-lane highway.

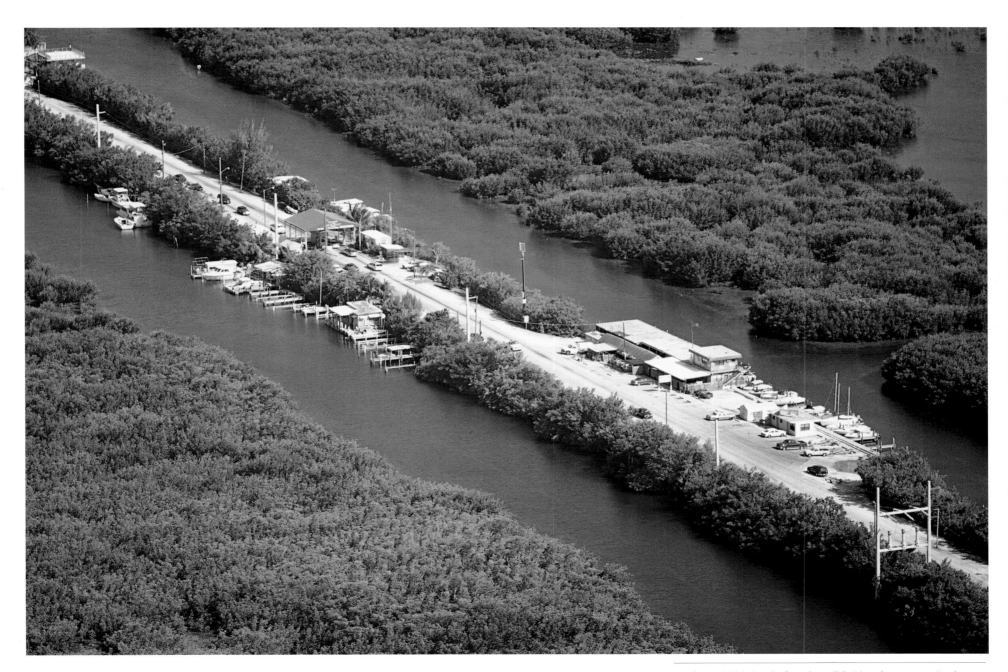

Highway 905A just before the toll bridge that crosses Card Sound. This was the original road into and out of the Keys before a new highway was built over the railroad right-of-way in 1938.

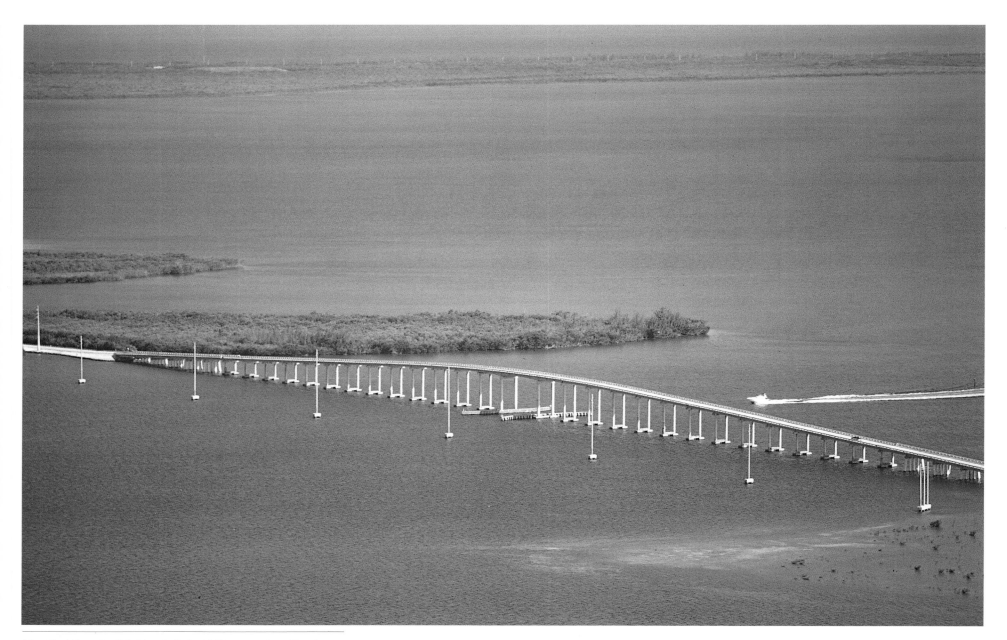

The Card Sound toll bridge, built in 1969, crosses from Key Largo to the mainland and separates Card Sound and Barnes Sound. In 1928, when the first Overseas Highway opened, automobiles crossed on six small bridges and one long bridge with a swing bridge to allow boat passage.

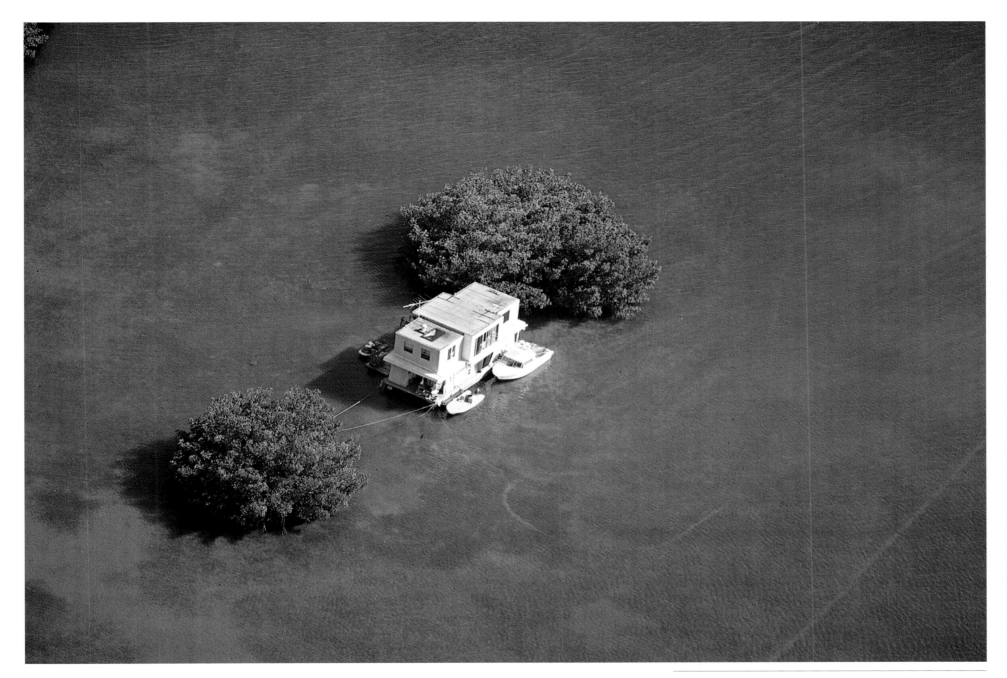

Houseboat squatters have staked out a little bit of heaven between two mangrove islets in Card Sound.

59

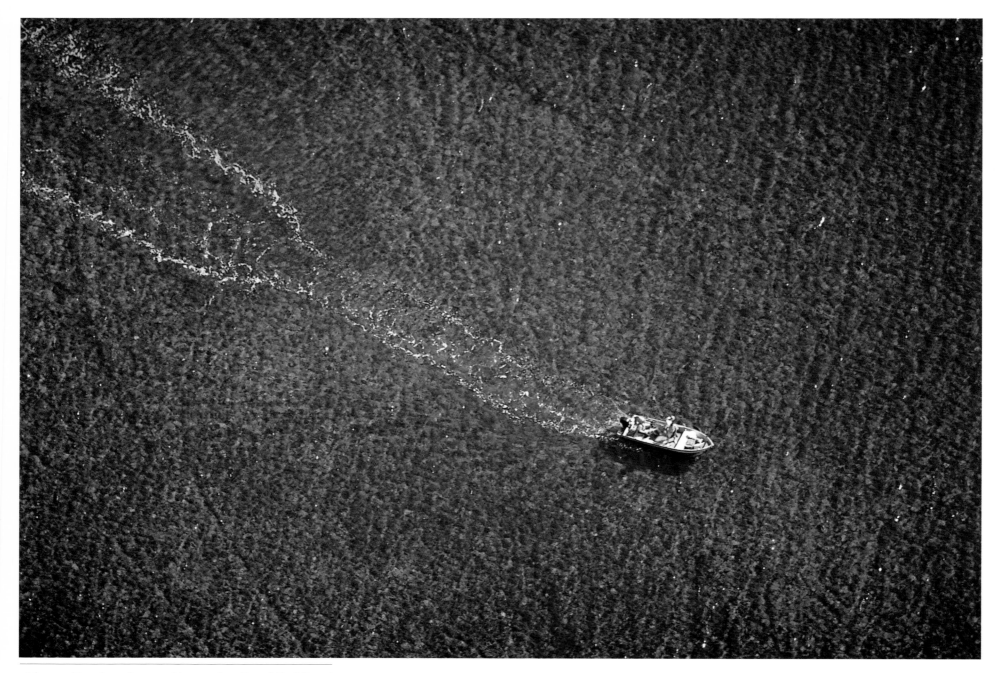

A boater skirts along the emerald green shoreline of Card Sound.

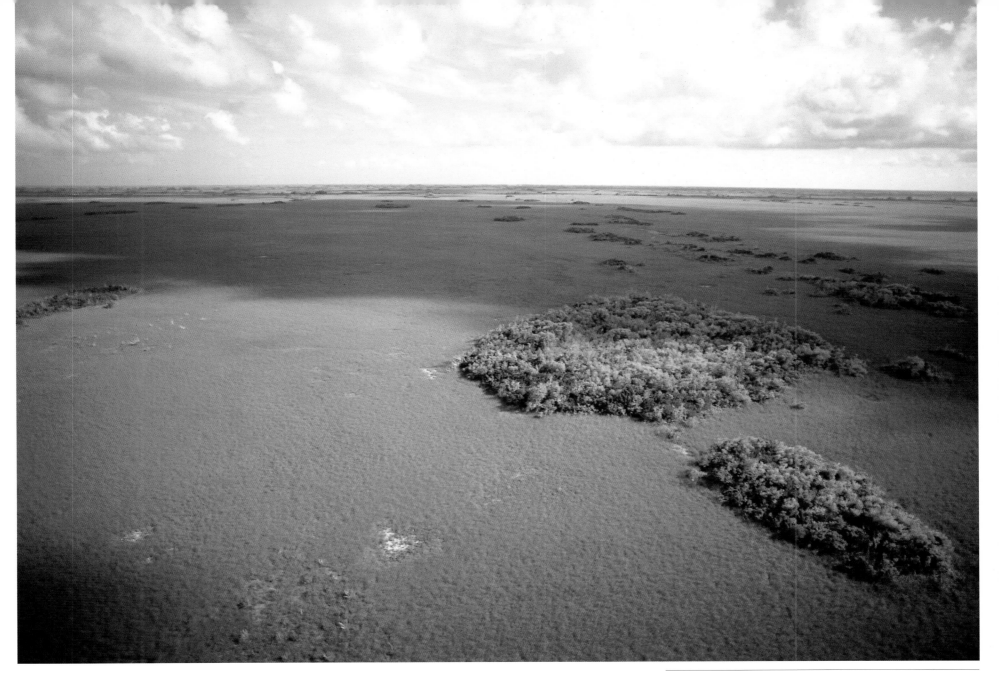

The vast watery grasslands of the Everglades National Park near the visitor center and campground at Flamingo. Trees grow on higher ground, creating "islands," known as hammocks, in the River of Grass.

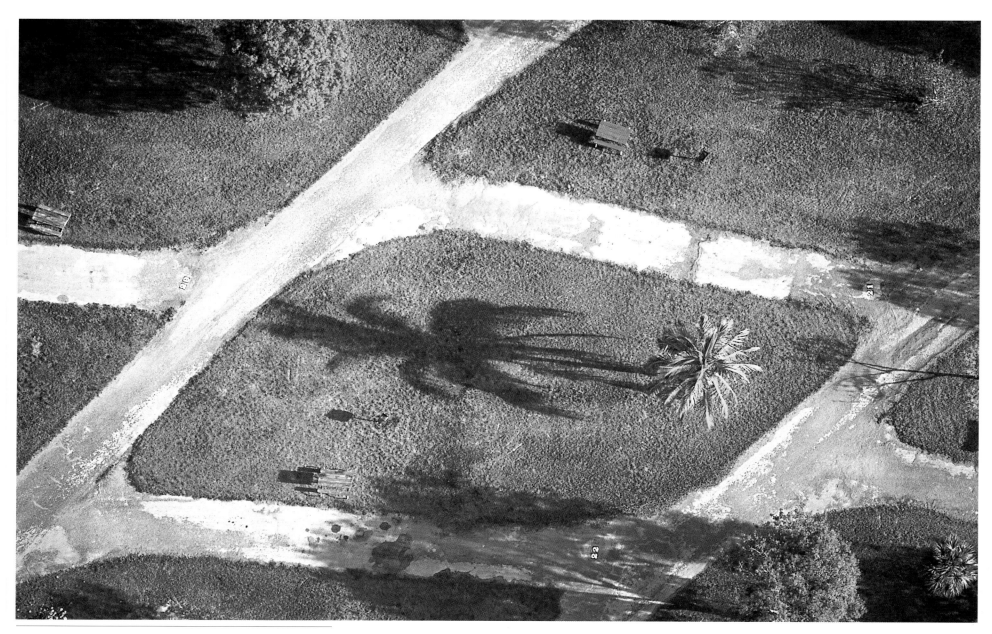

A lone palm tree casts a long shadow in the early morning sun at a Flamingo campsite in the Everglades National Park. The visitor center at Flamingo also offers lodging in motel-style rooms, interpretative talks by rangers, boat tours, boat rentals, and hiking and camping information.

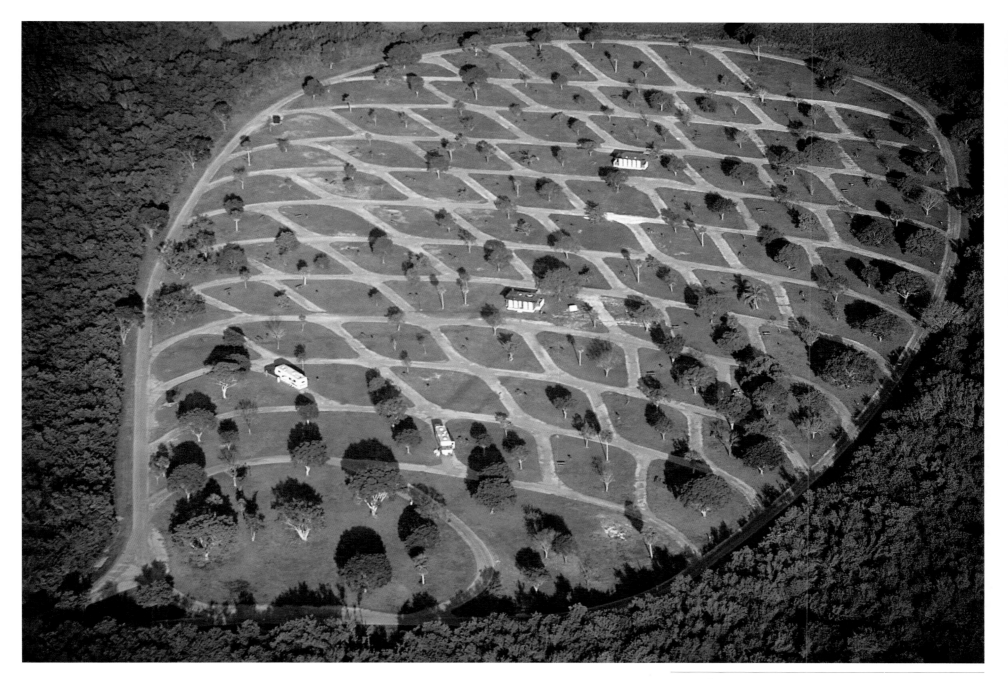

Unusually vacant, this RV park at Flamingo in the Everglades National Park has a pineapple shape when seen from above.

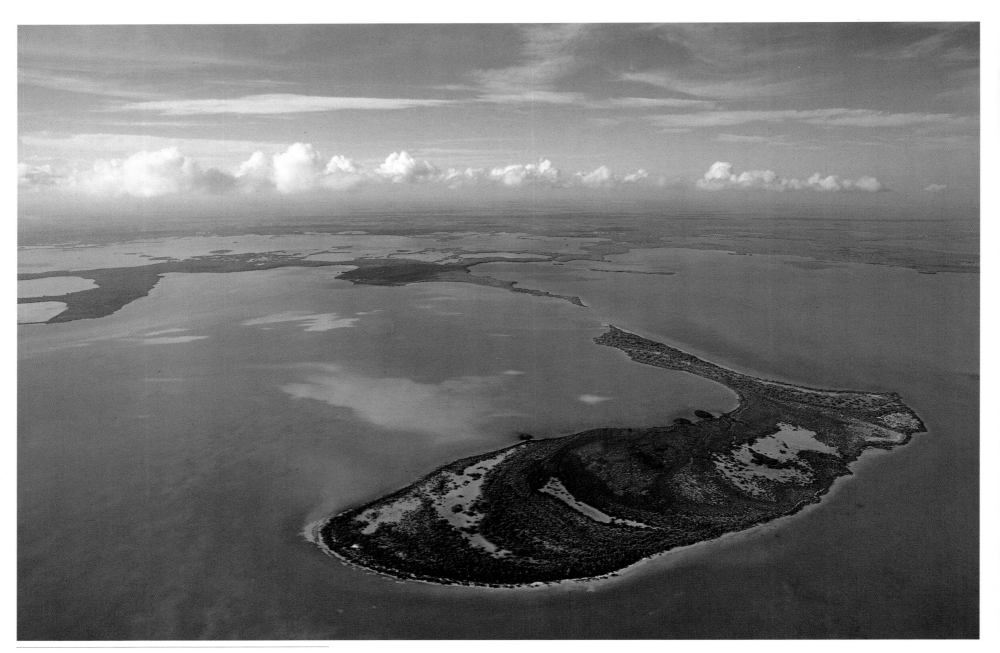

I have James Wyatt of Wyatt Aviation to thank for this shot of
Deer Key in Florida Bay pretending to be the whole state of
Florida—one of those places that can only be appreciated from
above.